Contents

Introduction
Leo Duff
1

Only Fire Forges Iron:
The Architectural Drawings of Michelangelo
Patrick Lynch
5

Old Manuals and New Pencils
James Faure Walker
15

'A Journey of Drawing: an Illustration of a Fable'
John Vernon Lord
29

Visual Dialogue: Drawing Out 'The Big Picture' to
Communicate Strategy and Vision in Organisations
Julian Burton
39

The Beginnings of Drawing in England
Kevin Flynn
47

Electroliquid Aggregation and the Imaginative
Disruption of Convention
Russell Lowe
59

What Shall I Draw? Just a Few Words
Phil Sawdon
69

Towards a Life Machine
Stuart Mealing
81

In Discussion with Zandra Rhodes
Leo Duff
91

Algorithmic Drawings
Hans Dehlinger
101

Drawing a Blank
Peter Davis
107

A Dialogue with Joanna Quinn
Ian Massey
115

Drawing – My Process
George Hardie
125

Drawing:

The Process

Edited by

Jo Davies

and

Leo Duff

intellect™
Bristol, UK
Portland, OR, USA

First Published in 2005 by
Intellect Books, PO Box 862, Bristol, BS99 1DE, UK

First Published in USA in 2005 by
Intellect Books, ISBS, 920 NE 58TH AVE. SUITE 300, Portland, Oregon 97213-3786, USA

Book and Cover Design: Joshua Beadon – Toucan
Copy Editor: Wendi Momen

With special thanks to Peter Till for use of cover illustration.

The CD ROM *Drawing -The Process,* containing edited works and associated texts of the fifty artist-designers who took part in this exhibition, is available from:

Leo Duff, Drawing Research, Kingston University, Knights Park, Kingston Upon Thames, Surrey KT1 2UD
l.duff@kingston.ac.uk

A catalogue record for this book is available from the British Library
ISBN 1-84150-076-3

Printed and bound in Great Britain by 4edge Ltd.

Drawing – The Process LEO DUFF

When we think of drawing now do we think of it differently from those living and working in, say, 1910, 1940 or 1980? Yes we do. At least those of us practitioners using drawing as part of our working process do, regardless of the discipline in which we work. We use drawing as assistant to thinking and problem-solving, not only as an aid to seeing more clearly nor as a means to perfecting realism. It is interesting to see in Tate Modern the inclusion of working drawings, as in the recent Bridget Riley and Edward Hopper exhibitions, for example. The fascination with drawing from the artist's or designer's point of view is the inconclusive way in which it works within, yet moves our practice forward. Drawing helps to solve problems, to think and to develop the end result. This may be the combination and juxtaposition of colours for the composition of a painting, design for a mass-produced jug or textile, visualisation for a children's book or a description of how to do something.

Laypeople enjoy examining working drawings associated with recognisable works of art as they feel they can be 'in on' the magical and secret world that is the mind of the artist. Recent advertising campaigns for cars, computers and sportswear have included reference, with much artistic licence, to the lengths a designer goes to create the most desirable products for us to buy. This allows insight into the sophisticated process leading to the purchase we are about to make.

All drawing is a serious business. How naïve to think that the simple and minimal line placed on a page by Picasso, or the slick Leicester Square caricature of a tourist, were achieved without the backing of hours, days, weeks of 'practice'. If drawing is something we can learn, then why do girls around the age of ten and boys at about fourteen give it up as something they feel they cannot do? No matter how 'good' or 'bad' a drawing is, the knowledge that it can always go a step further is perhaps the crux of the continued and rapidly expanding debate about drawing and its place in art, design, media and communication practice. In China it is common, in fact essential, that young art students perfect figure drawing before moving onto the next stage of creativity, basic design and compositional exercises. Using imagination or drawing without academic purpose is far from being on the agenda at the beginning of their studies. Here, in the western world, we encourage imaginative originality in drawing with little reference to skill or academic correctness. Two very different approaches of thinking and of drawing.

The aesthetic qualities of drawing are as difficult to pin down as the 'perfect' drawing is. Equally elusive are the aesthetic qualities of drawing as part and parcel of the creative process as witnessed in the sketchbooks, working drawings, plans and diagrams of practitioners in any discipline. Frequently drawing alludes to a world neither yet discovered nor understood, typified by the blackboard drawings of Rudolph Steiner or the mathematics of Professor Roger Penrose. In this way drawing can tantalise our curiosity, feed our imagination and offer new ideas to our own work.

As a catalyst for change, the process of drawing provides constant

challenges and routes to solutions. The essays written for this book cover a broad variety of approaches to drawing. The intention is to provide more viewpoints on, and insights into, how, and why, we draw. The intention is not to present answers – but studies on the process of drawing. These include references to oceanography, graffiti, illustration, product, textile and fashion design, architecture, illustration, animation and calligraphy. Under discussion is a range of media and practice allowing us new breathing space, clear of any concept of there existing a finite way to draw, or to think about drawing.

Leo Duff

Only Fire Forges Iron:

PATRICK LYNCH

Patrick Lynch is principal of
Patrick Lynch architects and he
teaches at Kingston
University and The
Architectural Association.
He studied at the
Universities of
Liverpool and
Cambridge and
L'Ecole
d'Architecture
de Lyon.

 The Architectual Drawings of Michelangelo

'Sol pur col foco il fabbro il ferro'
(Only fire forges iron/to match the beauty shaped within the mind)
Michelangelo, Sonnet 62'[1]

The architectural drawings of Michelangelo depict spaces and parts of buildings, often staircases and archways or desks, and on the same sheet of paper he also drew fragments of human figures, arms, legs, torsos, heads, etc. I believe that this suggests his concern for the actual lived experience of human situations and reveals the primary importance of corporeality and perception in his work. Michelangelo was less concerned with making buildings look like human bodies, and with the implied relationship this had in the Renaissance with divine geometry and cosmology. I contend that his drawing practice reveals his concerns for the relationships between the material presence of phenomena and the articulation of ideas and forms which he considered to be latent within places, situations and things.

Michelangelo criticized the contemporary practice of replicating building designs regardless of their situation. The emphasis Alberti placed upon design drawings relegated construction to the carrying out of the architect's instructions, and drawings were used to establish geometrical certainty and perfection. Michelangelo believed that 'where the plan is entirely changed in form, it is not only permissible but necessary in consequence entirely to change the adornments and likewise their corresponding portions; the means are unrestricted (and may be chosen) at will (or: as adornments require)'.[2] In emphasizing choice, Michelangelo recovers the process of design from imitation and interpretation of the classical canon, and instead celebrates human attributes such as intuition and perception as essential to creativity.

The relationship of Michelangelo's 'architectural theory' to his working methods leads James Ackerman to study his drawings and models and to conclude that he made a fundamental critique of architectural composition undertaken in drawing lines instead of volumes and mass. 'From the start', Ackerman, suggests, 'he dealt with qualities rather than quantities. In choosing ink washes and chalk rather than pen, he evoked the quality of stone, and the most tentative sketches are likely to contain indications of light and shadow; the observer is there before the building is designed[3]. This determination to locate himself inside a space which he was imagining was a direct critique of the early Renaissance theories of architecture which emphasized ideal mathematical proportions based upon a perfect image of a human body, rather than the experience our bodies offer us in movement in space[4] . '... Michelangelo directed (criticism) against the contemporary system of figural proportion. It emphasized the unit and failed to take into account the effect of the character of forms brought about by movement in architecture, the movement of the observer through and around buildings and by environmental conditions, especially, light. It could produce a paper architecture more successful on the drawing board than in three dimensions.'

The theories of Alberti, Sangallo, di Georgio, Dürer, et al.[5] were concerned with drawings which elicit a cosmic order , seen as inherent in the geometry of the human body. *'When fifteenth century writers spoke of deriving architectural forms from the human body,'* Ackerman claims that, *'they did not think of the body as a living organism, but as a microcosm of the universe, a form created in God's image, and created with the same perfect harmony that determines the movement of the spheres or musical consonances.*[6] Michelangelo criticized Dürer's proportional system as theoretical *'to the detriment of life'*, Pérez-Gomez claims in *The Perspective Hinge*. He quotes Michelangelo's critique: *'He (Dürer) treats only of the measure and kind of bodies, to which a certain rule cannot be given, forming the figures as stiff as stakes; and what matters more, he says not one word concerning human acts and gestures.'*[7] Such a shift in focus from intellectual to sensible integrity completes a turn outwards from the enclosed world of the medieval textual space of the Hortus Conclusus and scholastic cloister garden; outwards to an open realm of civil architecture in which corporeal experience and secular city life are championed over religious and metaphorical spaces.[7] Spaces became seen not as the representation of another ideal – such as an image of the garden of paradise – but rather, Ackerman suggests: *'the goal of the architect is no longer to produce an abstract harmony, but rather a sequence of purely visual (as opposed to intellectual) experiences of spatial volumes.'*[8]

Ackerman continues to infer that Michelangelo's drawings of mass, rather than indicating correctness of line, can be related directly to his compositional technique. Also, that matter and form are bound together through his working method – that drawing enabled him to think in a new way: *'It is this accent on the eye rather than on the mind that gives precedence to voids over planes.'*[9] Ackerman continues to state his case: Michelangelo's drawings *'did not commit him to working in line and plane: shading and indication of projection and recession gave them sculptural mass'.*[10]

The modelling of light as a means of orienting one's movement through space is best achieved and revised through model making. Typically, Renaissance architectural competitions were judged by viewing 1:20 models of facades as well as fragments of the building drawn at full scale.[11] The only drawings which existed for fabrication of buildings before the Renaissance were the Modano; 1:1 scale patterns of attic column bases or capitals.[12] The Modani slowly evolved from stage sets into Modello, architectural models, and often full-scale mock-ups of buildings, which enabled architects such as Michelangelo to *'study three-dimensional effects'*. Models enable scale to be judged as well as enforce the relationship between materiality and form. They also allow aesthetic decisions to be made, which relate solely to perception. For example, the intellectual matters of expression of structural logic may appear well in an orthographic drawing but be in fact detrimental to the actual quality of our experience of a building. Ackerman believes that Michelangelo used sketches and model-making *'because he thought of the observer being in motion and hesitated to visualize buildings from a fixed*

point... this approach, being sculptural, inevitably was reinforced by a special sensitivity to materials and to the effect of light'.[13] He viewed sculpture also as the art of making ideas, form, visible in matter.[14] Michelangelo in particular distrusted the ways in which architectural drawings can mislead us and rather his own drawings are less objects for scrutiny than sites of his own concentration and *'drawing out'* of his ideas. Alberto Pérez-Gomez claims that Michelangelo was suspicious of perspective, he *'resisted making architecture through geometrical projections as he could conceive the human body only in motion'.*[15] Conventional orthographic architectural drawings can be compared to anatomical sections, which cut through matter to reveal connections. The anatomical drawings of Leonardo da Vinci depict an objective view of still objects.[16] Michelangelo wished to infuse his cadavers with life and arranged their limbs in order to express the structure of human gestures. He sought, rather than a medical theory, to improve his capacity to depict the living body in movement.[17] This attention to the gestures we make is closely related to the manner in which his spaces allow for and celebrate passage and movement through doorways, up staircases and across the ground. His drawings of spaces also show people doing certain things there, and this is what enables us to read in his working methods the innate relationship between thinking and doing, and drawing and seeing.[18]

The drawings of Michelangelo's architectural projects which survive are made with chalk and pen and ink and often have figures superimposed over views of spaces. This leads me to propose that he was thinking about how the human figure perceives space and also how it appears in a space, whilst he was designing. For example, the façade drawings for the Porte Pia in Rome depict not only the material of the elevation, but also show a part of a leg striding out of the picture plane, through the gateway, towards the viewer. Micehlangelo's twin concerns for scale and movement are embedded in this moment of creativity. Similarly, the design of the library for the Medici library at San Lorenzo in Florence (also exhibited in Casa Buonarroti there[19]), transpose life size sketches of column profiles, actual views of staircases, sectional anatomical cuts through the building, fragments of limbs in movement with particular events unfurling in time. Michelangelo also drew faces in profile upon the profiles of columns, reflecting the importance of the figure in Humanist architecture as well as the emerging interest in the body as a model for meaning and communication of character.[20] The massiveness of the stone, its thickness and weight is drawn as a shadow, a dense profile, the space surrounding it alive with the movement of limbs. In a crude structural analysis, the Pietra Serena stone columns of the library vestibule are recessed, rather than proud or

disengaged from the walls, in order to bear the weight of the beams submerged beneath the ceiling surface above. They are bearing a load and this is expressed in the coiled spring of the brackets, which sit below the implied ground datum of the library floor height frieze. The stairway is set in a space of compression; it is small, very tall, with light only entering from above. The columns bear weight downwards

and we make a corresponding movement upwards toward the light, away from the chthonic realm of matter and weight. The implication of a hierarchy suggests Michelangelo's Neo-Platonism as well as his religious piety.[21] The library and its enlightening books are set above the darkness of the mundane life of the city. The staircase articulates this movement as a psychological shift also; we are led inexorably upwards, the architect drawing us towards the drama of the spatial and literary elucidation of the library.

A drawing of the reading booths not only shows a figure seated, reading, but also, drawn on the same paper we see a hand turning a page. The space a body takes up is cast as the form of the architecture; architecture the presence of human absence, a residue of movement, the setting for life.

In rejecting the means of representation of earlier Humanist architects, Michelangelo formulated a modern aesthetic sensitivity to the act of creativity as a spontaneous and memorial whole to which nothing has to be added 'to make it better... Unity consists in act'.[22] The act of drawing revealed the power of the mind to see in matter the immanence of forms, the presence and emergence of ideas. Michelangelo expressed this Neo-Platonic passivity simultaneously with a celebration of the compulsion to imagine forms within things: 'No block of marble but it does not hide/ the concept living in the artist's mind-/ pursuing it inside that form, he'll guide/ his hand to shape what reason has defined.'[23] As an anti-theory, or call to the creative contingency of human responses to situations, Michelangelo's comments upon architectural composition expose the academic reproduction of prototypes to the modern critique of originality, autonomy and individual virtuosity on the one hand, and the potency of place, action and situation on the other. His drawings are records of action and thought. Extemporary performances of imagination and skill combine a material sensibility with care for the appearance of things inherent in the ways things come into being. Michelangelos' drawings suggest that how we do something enables what we do to occur. Drawing simultaneously records and reveals the correspondence between speaking and doing, making and imagining, things and ideas, imagination and time, materiality and the immaterial: "*Only Fire Forges Iron.*"

[1] George Bull (ed)., *Michelangelo, Life, Letters and Poetry*, trans. Peter Porter. Oxford: 1987, pp. 142 & 153. The title of this essay is my translation of Michelango's Sonnett 62.

[2] Letter fragment to Cardinal Rodolfo Pio (?) cited in James Ackerman, *The Architecture of Michelangelo*. Harmondsworth: Penguin, 1970, p. 37.

3 ibid. p. 47.

4 ibid. p. 43.

5 For a general description of Renaissance architectural theory see Rudolf Wittkower, *Architectural Principals in the Age of Humanism*. London: 1949; and Erwin Panofsky's work also, *Idea... 1924*, etc.

6 Op Cit. p. 387. Cited in Alberto Pérez-Gomez, *The Perspective Hinge*. MIT, 1997, p. 41. He is quoting from Condivi's *Life of Michelangelo* cited by most scholars as the source of the undated fragment which remains of Michelangelos' architectural theory, Lettere, see C. de Tolnoy, *Werk und Weltbild des Michelangelo*. Zürich: 1949, p. 95.

7 See Rob Aben and Saskia de Wit, *The Enclosed Garden*. Rotterdam: 2001.

8 Op Cit. p. 28.

9 ibid.

10 ibid. p. 155.

11 The recently opened Museo Della Opera Del Duomo in Florence houses a selection of models particularly interesting for our discussion as they are incomplete and show drawn lines indicating where timber portions were to be added or where they have been removed. The drawn lines are rough and not intended for viewing.

12 Cf. 'Modani were not only the sole "instrumental" drawings absolutely "required' for the construction of a building until the Renaissance, but they were also fertile ground for displaying the architect's erudition and capacity for invention.' Op Cit. p. 107.

13 Ackerman, Op Cit. pp. 47-8.

14 Cf. La Carné Terre, Sonnett 197, Michelangelo: 'Flesh turned to clay, mere bone preserved (both stripped of my commanding eyes and handsome face) attest to him who earned my love and grace what prison is the body, what soul's crypt.'

15 Op Cit. p. 41.

16 Michelangelo considered Leonardo to be a technician. His work was scientific, expressing no artistic worth. Leonardo's ingenuity extended to the way he cut up the figures he exhumed – and they were pathological documents used to train doctors up until the 19th century.

17 Pérez-Gomez, Op Cit.

18 The importance of working in a particular way through certain media is still an important part of contemporary theories of practice. For example, the emphasis upon the role of computers in drawing spaces is closely bound to the act of conceiving spaces and new spatial conditions. The academic view which Michelangelo criticized developed into the Post-modernist legacy of the beaux-arts tradition in which plan composition – the invisible – is considered superior to perceptual veracity the real (Cf. Hal Foster, *Compulsive Beauty and The Return of the Real*, reprinted MIT 2001). In many ways, the over-emphasis upon the importance of drawing as a means of composition, rather than drawing as a means to 'see', is one of the principal causes for conflict in contemporary architecture (Cf. Vittorio Gregotti, *Inside Architecture*, MIT, 1996. See especially the chapter 'On Technique' (pp.51-60). The way in which one draws something enables it to be made in a particular way. CAD drawings of curvilinear forms can now be

sent directly to a factory where a manufacturer can cut the shape immediately from the architect's pattern-drawing. This replicates in part some of the methods of Renaissance architects in which the only drawings, which existed for fabrication, were the Modano. Most contemporary architects use CAD to either show perspective views of space or to make forms autonomous from hand-work and the tactile qualities of drawing which connect us immediately to the hapticity of spatial experience. Today, new buildings often disappoint us: they are not so perfect as the CAD images which we have seen of them, people and weather intrude in reality and mar the effects of the architect's dream-like visualization of virtual light and dislocated atopia. Like Leonardo's anatomy drawings, modern buildings are often arid and enervating spaces, lacking material depth; all the shiny surfaces and brittle reflections miscast us as intruders in the private fantasies of the designer; we flicker there like ghosts. The relationship between lived experience and its supposed opposite, the objective view point, can be seen clearly not only in the god-like view of an aerial perspective but in the architecture which comes from these images. Can we see in modern techniques of drawing a clue to the same immateriality of the spaces? Certainly, the example of Michelangelo suggests not only that what and how you draw something affects what you draw, but also what you think and perhaps, more importantly, how you think. This is clear in the resulting material quality of spaces and clearly shown in the design drawings. I suggest that the essential difference between the work of contemporary architects such as Norman Foster and Frank Gehry, and Michelangelo, is the exact ontological significance of matter and form and their relationship made possible in drawing and modelling and other modes of description. See Robert Harbison, *Reflections on Baroque*, Reaktion, 2001, for an attempt to argue that contemporary architects such as Coop Himmelblau and Gehry are 'neo-baroque' and not simply drawing meaningless shapes; and also my refutation of Harbison in my review of this book in *Building Design* 09/03/01.

[19] See *An Invitation to Casa Buonarroti*, exhibition catalogue, Milano: Edizioni Charta, 1994.

[20] Cf. Ackerman Op Cit. p. 37 and see also Dalibor Vesely, 'The Architectonics of Embodiment', and Alina Payne, 'Reclining Bodies: Figural Ornament in Renaissance Architecture', ed. George Dodds and Robert Tavernor in *Body and Building: Essays on the Changing Relation of Body and Architecture*, MIT, 2002.

[21] Cf. *The Cornucopian Mind and the Baroque Unity of the Arts*, Giancarlo Maoirino, The Pennsylvania State University Press, 1990: 'Beauty could not be severed from figuration in Neo-Platonic poetics, since nothing "grows old more slowly than shape and more quickly than beauty. From this it is clearly established that beauty and shape are not the same" (Ficino). Shape consists of "unfabricated" mass, whereas arrangement, proportion, and adornment refer to external criteria of beauty whose futility Michelangelo pinned to empty skulls, fleshless skins (Last Judgement) and poetic lines: "Once on a time our eyes were whole/every socket had its light. /Now they are empty, black and frightful, /This it is that time has brought." Inevitably the process of time eats away at beauty.' p. 18.

[22] Ficino, *The Philebus Commetary 300*, cited in ibid. p. 28. In Philebus, Socrates shows that because we can draw a circle, a circle is a form (eidos) which pre-exists awaiting our discovery of it. Plato infers that the ideal order of things is present and can appear within the sensible order of reality, if only partially and provisionally in language and art. This is the basic premise of phenomenology also: ideas reside in things: *Collected Dialogues*, Plato, Oxford, 1992.

[23] Michelangelo, Sonnet 151, Op. Cit.

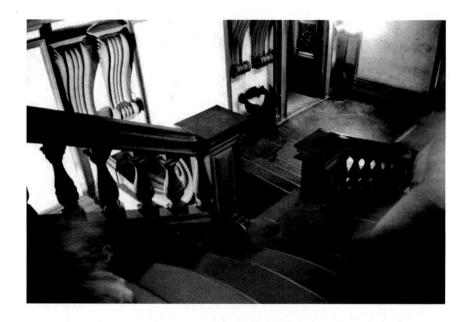

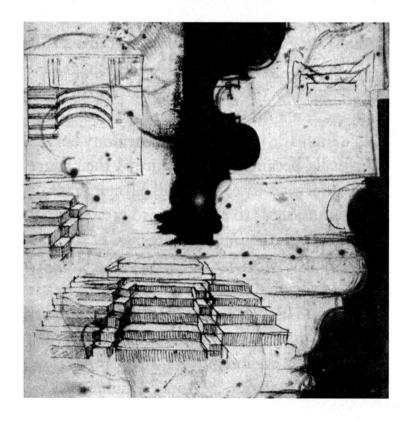

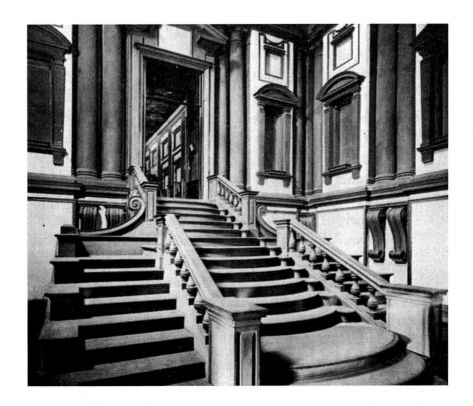

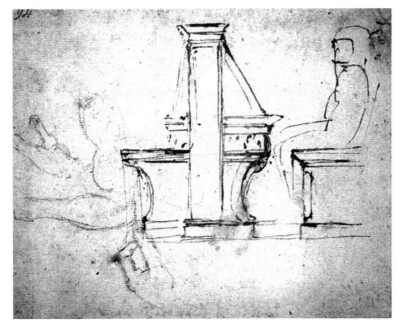

JAMES FAURE WALKER

James Faure Walker is Senior Research Fellow in Fine Art at Kingston University (AHRB Fellowship). He is also a tutor on the interdisciplinary M.A., Drawing as Process.

He studied at St Martins and the Royal College of Art, London. Recent one-person exhibitions include the Whitworth, Manchester; the Mariani Gallery, Colorado; the Colville Place Gallery; Galerie der Gegenwart, Wiesbaden. He has been integrating computer graphics with painting since 1988, exhibiting widely overseas through ISEA, SIGGRAPH, Computerkunst, Digital Salon, (see www.dam.org/faure-walker). In 1998 he won the 'Golden Plotter' prize in Gladbeck, Germany. Group shows include the Hayward Annual, Serpentine Summer Show, John Moores, Artists in National Parks, the Post Modern Print at the V&A. In 2001 he curated 'Silent Motion' at the Stanley Picker Gallery, featuring Muybridge alongside contemporary digital works. (www.kingston.ac.uk/picker/silentmotion).

He was a founder of Artscribe magazine (1976) and editor for 8 years. His writings have also appeared in Wired, Studio International, Modern Painters, Mute, Computer Generated Imaging, Art Review, 100 Reviews Backwards, and in catalogues for the Tate, Barbican, Siggraph, and Computerkunst.

 Old Manuals and New Pencils

The Intolerant Eye

'Oh, so they could draw,' exclaimed two visitors with some relief when they reached the room of drawings at the Tate Modern's Picasso and Matisse exhibition last summer. After an initial smirk, I hesitated. I wasn't sure they were right. For some days before, and on the tube en route to the exhibition, I had been reading Ruskin's 'Elements of Drawing' of 1857 – a treasured first edition I picked up as a student. Being absorbed in Ruskin's strictures against the slapdash, wary of contaminating my taste by looking at bad art (Claude is 'base' and Salvator Rosa 'evil'), I found myself looking aghast at these thick and clumsy lines – imprecise, untruthful, coarse, lazy, rushed, approximate. 'All great art is delicate,' he declares . A good line *'should be like a well-managed horse'*.[2] This was not the right primer for the show.

These days we are unlikely to be quite that opinionated about drawing. Few would want to explain why a drawing was outrageously bad – you chuckle knowing that it is meant to be like that. The most impressive drawing show that I have seen in recent years was the Polke exhibition at MOMA in 1999, and if I think of it as 'creative' it is because of its fearless, searching energy – from a scrawl in a private sketchbook to a vast Spiderman fantasy. I wonder what Matisse would have made of it. Would he have sensed an underlying competence, a discipline? Or a degenerate, diseased mind?

For generations of nervous art students the key to getting onto a good course was the portfolio of drawings. The interview panel would leaf through these in silence. If they weren't up to scratch no amount of smart talk would get you through. It wasn't just about ability or perseverance or 'being able to draw' – that could mean quite different things to different people. Drawing was the touchstone, outside of fashion, beyond argument, the foundation of art. Whole cultures were categorised by their use of line and form, some pure and classic, some degenerate, confused. According to Ruskin, half the National Gallery was well below par and would do the student serious educational damage: we should look at Rembrandt and Michelangelo in moderation in case we picked up bad habits. It may now sound nutty to dismiss whole periods of art history and drawing, but perhaps we are no better. We have become art tourists, afraid to make any noise that might cause embarrassment. We are there to appreciate, to consume uncritically. We look, but not too hard.

Drawing is supposed to be flourishing with special events and new courses. Yet it is also – otherwise why the need for treatment? – in trouble. It is like a discipline that has lost its centrality, pushed to one side by new technology, photography, and art theory. So we have to whip up enthusiasm. Look at all the different types! Japanese brush drawings, porno graffiti in toilets, plumbing diagrams, medieval herbals, Rupert Bear, Ingres. It's all drawing! Draw! We say, like teachers desperate to

get twelve year olds reading, happy even if it's Beckham's autobiography. There is a plus side. Each niche of contemporary art – video installation with water, miniature neo-geo, fantasy landscape, and web activism – is ringed round with ideology. Drawing remains just drawing, and artists turn to it as a form of therapy. Aside from the occasional dictatorial life-drawing tutor, no one is out to control the territory. Everyone can be an individual; everyone can do his or her own thing. It can be rigorously architectural or funky.

Open-eyed and Linear

So the last thing we need is an argument about line versus tone, or a spat about quality, anything controversial that would disturb the mood music, the purring adulation of the Tate's audio-guide. *'Observe the mastery of the uncoiling arabesque...'* Study those sinuous Matisse odalisques. You don't need Ruskin whispering: *'The perfect way of drawing is by shade without lines'*[3]... *'No good drawing can consist throughout of pure outline'*.[4] An expert art theorist would spin out some sophistry to show that both Ruskin and Matisse were purists in their own specific way. They were quite reconcilable. We don't need to take sides. It's all relative to cultural context. Don't judge. Line, tone or anything, is OK. Do a crossword, a cartoon, life drawing or shopping list, it doesn't matter. Just keep filling that sketchbook!

Can you really care about drawing without making value judgements, without some intolerance? Klee had strong words about misunderstanding the generative aspects of line; about thinking the sole function of drawing was mimesis. Cartoonists have opinions on what they think of as the conceptualism of the YBAs. And there's the species of minimalist drawing bordering on fetishism, the palest stain on rice paper, that attracts ferocious ideological argument. Like Jehovah's Witnesses, everyone else has to be wrong. Life Drawing itself has sharp divisions between measurers and therapists. So the bland platitudes we find ourselves muttering at a drawing conference – where academics agree it is a good thing to study drawing in a general way – are far removed from the angst of the studio.

Drawing itself can require total absorption, complete silence, the belief that nothing else matters but how this line turns. It is not just looking and making marks, but analysing, editing, discriminating, excluding, judging. An earlier generation of students had to reinvent itself for each drawing tutor depending on whether he was a traditionalist or a modernist. Did this tutor approve of cross-hatching, of putting in the eye-lid? Would this one shout 'there are no lines in Nature' if you brought in an H pencil? It is hard to imagine such disputes ever percolating into the letters page of a current art magazine. If drawing is covered in an article it is all one-sided appreciation; technique is

called methodology and talk covered in intellectual fuzz. A hundred years ago it was quite different. The way you drew, even the way you decided to draw, determined everything else. Dip into Walter Crane's marvellous 'Line and Form' of 1900:

Outline, one might say, is the Alpha and Omega of Art. It is the earliest mode of expression among primitive peoples, as it is with the individual child, and it has been cultivated for its power of characterization and expression, and as an ultimate test of draughtsmanship, by the most accomplished artists of all time.[5]

Line may be regarded simply as a means of record, a means of registering the facts of nature, of graphically portraying the characteristics of plants and animals, or the features of humanity: the smooth features of youth, the rugged lines of age. It is capable of this, and more also, since it can appeal to our emotions and evoke our passionate and poetic sympathies with both the life of humanity and wild nature, as in the hands of the great masters it lifts us to the heavens and bows us down to earth: we may stand on the sea-shore and see the movement of the falling waves, the fierce energy of the storm and its rolling armament of clouds, glittering with the sudden zigzag of lightning; or we may sink into the profound calm of a summer day, when the mountains, defined only by their edges, wrapped in soft planes of mist, seem to recline on the level meadows like Titans and dream of the golden age.[6]

In an age where TV dinosaurs roam the savannah, where a family snapshot can be filtered into a line drawing in PhotoShop, our perceptions of nature are less open-eyed. We take simulations for granted. A child at the zoo exclaims that the alligators 'don't look real'.

There may never have been, and never will be, just one 'true' way to draw, but it helped to think there was. There have always been different objectives – a flattering portrait and a drainage diagram have different uses. If you feel 'art' drawings should be segregated from caricature or diagrams it is worth bearing in mind that there is no simple translation for the term 'drawing' in Chinese. They would say 'painting with no colour'. So we may be talking at cross-purposes the moment we talk about drawing as a universal language, and make hopeful noises about the merits of drawing. Or of not drawing, as one student put it to me, because drawing just shows up your inability. It's better to keep ideas secret in your head. Some artists have even more convincing arguments for not drawing: if they are making an installation, they don't want to cloud their impression before they case the space; or a painter may prefer to jump straight into a painting without the safety net of a preparatory drawing; other artists maintain that what they do with a video camera is 'drawing'.

The Agnostics

We can muddle along for a while without defining drawing – we more or less know what it is – but sooner or later we hit a brick wall when confronted by someone, or an entire discipline, that thinks about it in a completely different way. Should the medical illustrator, that

minimalist making a fetish of twelve dots on rice paper, the car designer, the life-drawing tutor, the Chinese calligrapher, the engineering draughtsman using CAD, all be able to understand the finer points of each other's 'drawing language'? Could they all have started from the same set of principles? Is it essential to follow and copy the same models, the same masters? Could you educate yourself entirely from a book, some updated and more inclusive 'Elements of Drawing'? How many chapters should there be on PhotoShop, or should the drawing tips be in the PhotoShop manual? What is a drawing expert?

Questions, questions, and we can parry them with the conventional wisdom that drawing is really learning to see. But what kind of answer is that? It is like saying drawing is 'mark-making'. Do we set up a still life, draw from memory, or spatter ink on the floor? If someone tells us drawing is essentially about eye and hand co-ordination then a clever student could propose a game of tennis, which is at least an art form with clear levels of accomplishment, agreed rules and boundaries, and you end up knowing who's best. Isn't the idea of a drawing competition a bit odd? Could it be set up as a knockout tournament? So it is understandable that we duck the issues and fall back on the Life Room as the easiest expedient, the place where drawing is most Drawing; where there is a model, something to measure, and an aura of concentration and obedience to unspoken laws.

Ruskin, Crane, and other manuals don't actually have much to say about life-drawing. Their cultural references, from botany to archaeology, to poetry are broader. True, drawing manuals would be directed toward the general reader more than art student, and nudity would have caused problems (Eakins was dismissed for having nude models in front of female students). But the idea that pictures of bored nude figures, sitting doing nothing, are the central defining achievement of western art – its Everest so to speak, an end in itself – would probably have struck them as perverse rather than traditional. Would they have recognized Frank Auerbach or Lucian Freud as great draughtsmen? My guess is they would have been perplexed by commentators who speak reverently of the human condition, the connection with the Old Masters. They would have registered the stylistic aberration, the mannerisms, the nakedness, and for them their sheer ugliness.

Why, in Auerbach, when the foreground or the figure is rigid and cuboid is the background, the sky, a flat backcloth? Why all the rubbing out? To speak of 'figurative' art and 'traditional' art in the same breath, as if it thereby some of the aura and authority of great art channels along an unbroken pedigree, is quite a twisted view. If you spend an afternoon at the National Gallery the connection between this late twentieth century idea and the Titians, the Gainsboroughs, Rembrandts, Pieros, Botticellis, is far from obvious (for Ruskin, of these Titian is the only one to be trusted, and Gainsborough is all *"gentlemanly flimsiness"*[7]). There are figures yes, but they are mostly there for a purpose, doing something somewhere, dramatised, naked

for a reason, not just 'being form', not just some ritualised incantation to Artness. Their emphasis, despite the differences, was on capturing character and movement, the poignancy of an event, and was as interested in plants, hills, streams, and old or flashy clothes as it was in the chores of art school routine. Drawings were made for these purposes. What was also lost, as a more modern consciousness dawned, was the dream of an ideal, the classical ideal, something that could be defined with a beautiful elegant line. Drawing had to become something different.

So when I arrive at a conference and the topic is digital drawing, or drawing digitally, I feel some disappointment when a talk turns out to be about embellishing routine life-drawings with PhotoShop filters, or using ready-made 3D jointed humanoids, or turning lively dancers into anonymous wire-frame sculptures through motion capture. All this can be interesting, but it is hardly earth shattering. It has a zombie correspondence course mentality. In fact at Siggraph,[8] the world's principal computer graphics conference, the newer internet-based art schools (Art Institutes, Full Sail) conduct life-drawing sessions to promote themselves (do the drawing, get the T-Shirt). It all has a point – in some of the sessions the drawing tablet or laptop is put on the easel. Digital special effects companies say they prefer candidates with folios of drawings to tech-heads, and the schools that feed them emphasise life-drawing as the best training for the eye. But this conception of life-drawing becomes so diluted as to be meaningless – circle for head, cylinder for torso – with the students not even looking at the bikini-clad model as they draw. It is just 'doing art'.

When I am in a postmodern mood I wander through the dialectics of style like an atheist, and any life-drawing is as good as any other. (Close your eyes when you draw. Fine. Who cares? Great. It's a bit like de Kooning. I am glad you like it.) But I can also inhabit the world of these manuals, and enjoy their prejudices, their technical tips. It makes you into a time-traveller, looking at familiar art from bizarre angles. Of course you don't need a manual to learn the 'craft' or to develop the appropriate narrow-mindedness. That can come naturally. With just a modicum of sensitivity you can understand the Pre-Raphaelite obsessive stare at static detail; or the uncoiling tendrils of Art Nouveau; or the doubting, grasping quivering of a Cézanne or Giacommetti's drawing; the comedy of a Dubuffet or a Polke. And like adjusting to a different ethos in the Life room, you look each time with different eyes. It is also quite possible to work in two completely incompatible styles on successive days, to participate in a video workshop in the morning and make correct/incorrect observations about a student's life-drawing in the afternoon.

Is this possible now because we are living in a more enlightened – or more knowing, cynical and self-conscious – age? Has 'drawing' moved on? (How would we know? Could it have moved backwards?) The generalisations may be absurd, but if one factor should give us pause for thought it is technology. In 'Elements of Drawing' Ruskin

writes of photography as the draughtsman's friend, providing better reproductions than engravings, and sources for landscape. Digital technologies really became relevant for the practical purposes of drawing in the eighties and nineties. If the significance has taken some years to register – it certainly wasn't an overnight revolution when suddenly a computer started 'drawing' – this is because it is not just one technology, but half a dozen, and these work in combination, and in a variety of fields from medical, military, engineering, cartographic, entertainment, art.

2D or not 2D

It is worth summarising some of these components. Computer Aided Design works from geometric primitives, lines and circles to immensely complex 'wireframe' models, and these forms exist in a 3D universe, and can be readily scaled and pulled around like elastic bands. The paint program starts from a moving point, a pencil, a brush, and though it is closer to traditional drawing – you can use a drawing tablet – it occupies a 2D plane where depth has to be implied by illusion. Digital photography allows any 'photograph' to be instantly available, and integrated into the 'canvas'. Paint programs themselves encompass every imaginable nuance of photo-processing, colour manipulation, brush and textural treatment. Any drawing on paper can be scanned and converted to a digital format where this vast range of tools and filters can get to work. The drawing that is originated, or treated in the computer can then be printed at the required degree of refinement, on watercolour paper if necessary.

There are other methods: drawings produced directly from programs written or tweaked by artists and output through plotters, a method going back to the sixties, perfected by artists such as Harold Cohen, Roman Verostko, Mark Wilson, Manfred Mohr, Hans Dehlinger, though the plotter is fast disappearing as a print technology.[9] And looking ahead, a new set of devices is moving from laboratory to marketplace – it has only been when cameras and inkjet printers became consumer items that they could be taken for granted as drawing accessories. Taking last year's Siggraph, as a guide, the next generation of gadgetry presupposes a 3D universe where any object can be twirled around, squeezed, re-skinned, and reproduced; both 3D scanners and 3D printers – where the scanned or created object is printed layer by layer – have become commercially viable products.

Also on the market are a number of motion capture systems, demonstrated by athletic dancers and martial arts experts, wearing the necessary sensor suits. These 'models' operate in shifts, with bursts of energetic gyrations on the stage – a podium framed by gantries of 3D sensors – followed by rest periods when they reading their mags. Still suited up like half-dressed divers they sit – unobserved – in their chairs like art school models. If you constructed an image this way would it count? Why

would it be more a 'drawing' if it was observed rather than captured? It may well be that what we end up calling drawing won't be challenged at all from this quarter, and drawing will have little relation to the 3D world. On the other hand it could prove an indispensable device. One team of artists had 'captured' Merce Cunningham's dance for hands this way, and produced an ever-changing drawing animation. One clear trend apparent among experienced digital artists – from illustrators to what you might call conceptualists – is a move into the more complex 3D programs, Maya being the favourite, or the more affordable ZBrush, which enables you to draw like you were modelling clay. Trying out these programs where your marks, your lines inhabit this malleable 3D world, as if you were touching, moulding, sculpting, lighting the form as you create it, is a seductive experience for anyone obsessed with drawing. Ruskin might have hesitated, but I like to think he would have had a go.

No one, not even the salesmen, suggest that these products provide more efficient substitutes for 'traditional' drawing skills. If anything there is too much respect for tradition. What would have Uccello done? The 'Battle of San Romano' looks like a low-powered 3D model, again, an artist to be avoided; too stylised, primitive, insensitive to nuance. Today our critics lose no sleep at all about 'truth to nature', about line versus colour, or the 2D versus 3D dialectic. Ruskin advocated copying a Durer or Turner engraving, square inch by square inch. The one context I know of where these images are still scrutinised for their effectiveness is the discipline that combines computer graphics with perceptual psychology.

Here they ask the same questions as Ruskin and Crane asked about drawing drapery: should the shading describe the contours of the folds or accentuate light and shade by flat tone? Sophisticated experiments have determined how many curvy lines are required to sustain the illusion, and bizarre diagrams present the same bumpy terrain as a contour map or crosshatched engraving. Ruskin avowed that there is much that is undrawable, such as the foam on waves, but that and much more has been accomplished in much the way he advocated: by understanding the momentum involved, the lighting, the hydraulics. As programs become more and more sophisticated this community is understanding more and more about the incredible refinement of the human eye. Again and again they turn to 'pre-technological' art to learn what is and isn't essential in making us see the way things are.

The Wisdom of the Manual

On the face of it there is this consensus about drawing, with just the odd 'inventor' demanding attention. Draw the noise of your drawing! The leaflet says our 'conventional ideas about drawing will be

challenged', but as we don't have any ideas about drawing – conventional or unconventional – we feel just an apathetic 'so what?'. Experimental drawing is a misnomer, like experimental weaving. Digital tools can simulate and far exceed traditional methods and this has helped confuse the issue. What is central in drawing? Does it make sense to say one kind of drawing is more fundamental than another? Is it essential to learn perspective and anatomy? Neither is emphasised as much as botany by Ruskin – more at home in the countryside than the city.

Make friends of all the brooks in your neighbourhood, and study them ripple by ripple.[10]

Both Ruskin and Crane, to a surprising degree, write of learning to accept happy accidents, to adapt the image to the material. They dwell on the qualities of B and HB pencils, ink, nibs, reeds, paper roughness and absorbency. But truth to material is a hard maxim when there is no material to be true to, no grain of resistance. And should there be a model *'out there'* when a photo, a 3D scan, a motion capture, a 3D program, could do all the hard work for you? Asking the question also presupposes the student is a proficient user of programs which themselves can take months, years to master. At the same time, what many colleges specialising in computer arts are finding is that technical training without the creative thinking part is not enough. But you cannot just add the creative part on as an afterthought. The trick would be to think out an approach to drawing that brings the capabilities of digital and the visual curiosity of enlightened drawing practice together. And that might mean drawing without a model at all, it might be better thought of as 'linear invention', something in its own right, something that might work to complement the photograph or the video.

Many a student has been cut down to size by a tutor correcting 'mistakes', there has always been some ambivalence about anything too objective and scientific intruding into the drawing class. Computers were seen this way – quite mistakenly – by fine art departments in colleges when they first appeared, especially when the students got the hang of them before the staff. But it's worth remembering that a liberal, more open-minded approach to drawing was the norm before such threats loomed large. This is from Kenneth Jameson's *You can Draw*, published by Studio Vista in 1980:

In drawing... this lack of 'rightness' is nearly always attributed to inability to cope with the intricacies of 'perspective'. What a pity perspective ever strayed from the field of science and optics, where it belongs, to the sphere of artistic expression where it does not. It is significant that very few colleges of art now teach perspective as such.[11]

Ruskin's adherence to studying nature, by which he meant studying the way a tree responds to climate and its terrain, the distribution of branches, leaves, and how leaves seen head-on differ from leaves seen sideways, and how they filter and reflect light – all this is familiar enough. What I had overlooked is how he also recommended copying

engravings, and photographs, even landscape photographs. He advocated drawing descriptively, revealing what you see in front of you, but he disapproved of any vulgar effect, sharp projection, *trompe l'oueil*; '*a thoroughly fine drawing or painting will always show a slight tendency towards flatness.*'[12] That might have ruled Picasso out, or perhaps not, as he took whatever he could from the Old Masters, including a respect for immaculate flat design, but it does possibly accord rather well with Clement Greenberg's thesis built around Jackson Pollock, and the subsequent close-toned colour-field painters. The point here is not that we should follow Ruskin's prescriptions literally, if at all, but to recognize that with a little amateur science he can still startle us to look again at what we thought we knew – like filling a basin with water stained with Prussian Blue and floating cork in it to determine the angles of reflection. It was certainly not drawing for drawing's sake.

On the face of it these drawing manuals are little help today, yet in flipping through them I find the contrast with my own received ideas instructive. There is an emphasis on copying 2D work, even the run-of-the-mill magazine illustrations of Ruskin's day, more of a sense of looking at how drawings actually work, a critical view which, as I have mentioned, links up in a curious way with research in computer graphics. There are the anachronisms – Ruskin asks you to go out into the road to choose a rounded stone – and there is a fireside manner that's vanished in a television age. There is now so much more information available to us. Ruskin or Crane never knew what it was like to fly over a landscape, to look at cloud layers from above, or see the earth from the moon. Nor would they have had the remotest idea that the revolutions of modern art would lead to an imperious Tate Modern that now dwarfs the National Gallery.

However we make drawings now, my guess is that they would have expected us to take advantage of the extra knowledge we have – of the scale of the universe, of DNA, of new materials, travel and technologies. Like the modernists who followed on, they could be both medievalists and keen scientists. If one thing links advocates of drawing through to these years it is a real curiosity about how things work. The more recent formulaic how-to-draw books – cats, yachts – are less hard-core, and have more anecdote than science inside. They tell us something of their intended readers. The 1943 Studio 'how to draw' series included Terence Cuneo's 'Tanks and How to Draw Them'. What is also striking is the continuity that existed between thinking and doing, between theory and practice, and between the amateur and the professional. We don't count on today's expert commentators being able to flesh out their observations with their own illustrations. The expertise is much more specialized: A travels round the Biennales, B does portraits and drawing crits, C writes drawing software, and D does the voice-over for the Titian drawings. None of them read *Scientific American*.

To produce a comprehensive 'Drawing Elements' today, with the philosophical breadth of Ruskin or Crane (who had inherited much from Morris); with updated science concepts; with an update about

conceptual art; with insights about the digital; and with the author's own illustrations, well, that would be quite something. On the other hand, if we assume such an undertaking is impossible, that might mean all this inherited knowledge just trickles away. What we need is a substantial Department of Drawing in a good college, not just an add-on. Forget the Life Room on Wednesdays and a week's PhotoShop training. This could be for real.

It is a good idea to throw a wobbly to panel members at a conference and ask about the future of drawing. My own hope is that the craft-based divisions between painting, drawing and printmaking – you could include photography and the digital – will continue to dissolve. With luck the pretensions of Fine Art will collapse. I would also hope that the art of line comes again to the fore.

1 John Ruskin, 'The Elements of Drawing', in Ruskin, *Three Letters to Beginners*. London: Smith, Elder & Co., 1857, preface p.xi.

2 ibid. p. 15.

3 ibid. p. 102.

4 ibid. p. 112.

5 Walter Crane, *Line and Form*. G.Bell & Sons, 1900 (page numbers refer to 1921 edition), p. 1.

6 ibid. p. 22.

7 Ruskin, Appendix p. 338.

8 Siggraph was held at San Antonio, Texas from July 21 to 26, 2002. See <www.siggraph.org>

9 See <www.dam.org/verostko> for an account of this drawing method.

10 Ruskin, p. 154.

11 Kenneth Jameson, *You can Draw*. London: Studio Vista, 1980, p. 46.

12 Ruskin, p. 76.

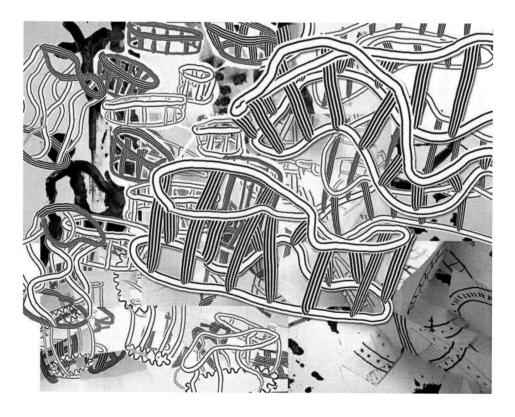

JOHN VERNON LORD

John Vernon Lord has been a practising Illustrator since 1960. He has written and illustrated several children's books, which have been published widely and translated into several languages. His book The Giant Jam Sandwich has become something of classic, having been in print for thirty years. The Nonsense Verse of Edward Lear won two prizes and illustrations for Aesop's Fables won the W.H. Smith Illustration Prize in 1990. More recently he has illustrated two Folio Society's editions: British Myths and Legends (1998) and the second volume of The Icelandic Sagas (2003).

Prof. John Vernon Lord's reputation and experience in education spans a period of 38 years at Brighton. He is without doubt the leading expert in narrative illustration in the UK and his contribution to the field of illustration in Higher Education across the UK is legendary.

'A Journey of Drawing an Illustration of a Fable'

Preamble

Drawings are visual ideas about form and space, about lightness and darkness. They involve the measurement and the selection of things, observed or imagined. Drawings have a lot to do with trying to make sense of the world as we know it, and what we have seen, thought about, or remembered. They are thoughts and proposals turned into vision. At the same time those who draw try to create new worlds and new thoughts, both technically and conceptually, and do so by trying to develop a new visual language – a world that no one else has seen and a way of drawing that no one else has previously attempted. Drawings encompass a wide range of activity: from doodle and sketch to something more elaborate; from rough scribble to neat diagram; from first thoughts to last; to clarify or make a point; to record and to remind us of something; to enjoy the making of marks for their own sake with whatever instrument and upon whatever surface. They are messages and signs and they end up as themselves with a life of their own.

Finding it 'difficult' to draw is perhaps just as important as being possessed with a certain amount of natural talent for it. Any deficiencies we may have in drawing, and the way we overcome these inadequacies, often brings about a unique character to our images. Sound draughtsmanship can be extremely dull if conventionally wrought. Individuality is as much about the shortcomings in our nature, or weaknesses, as about our strengths. Awkwardness in drawing is as interesting as fluency. We make marks with pencil, crayon, ink or paint but the marks we don't make are just as important as those that we do. Nothing may well be something.

In the same way that good grammar alone will never necessarily write a good story, an illustrator has to go beyond draughtsmanship to make a good picture. There has to be a complexity of ideas *inside* the drawing, something that intensifies a text without overpowering it. It is a fine balance.

This paper is a 'stream of consciousness' based on diary entries and a memory of what was going on in my head when I drew a single illustration for a fable. The illustration is not a particular favourite of mine but it is one that I can recall doing very clearly. It was the third out of 110 illustrations that I drew for *Aesop's Fables*, published by Jonathan Cape. The illustrations in the book subsequently won the overall prize in the W.H. Smith Illustration Awards of 1990. What follows is an attempt to describe an illustrator's thought processes from initial pencil drawing through to the final illustration. Drawing from the *words* of the fable was the catalyst.

A Stream of Consciousness

First day: After lunch I enter my studio. Sit on my swivel chair and wheel it in front of my desk. Switch on the radio and look through the

Radio Times to see what's on the radio. I place before me another sheet of Kent Hollingworth Hot Press paper (smooth finish).

I feel good because I've already got an illustration 'under my belt' today. Which fable shall I illustrate now? I think I'll start to draw the fable of 'The Crow and the Sheep'. What does the text have to say for itself? Here's Roger L'Estrange's 1692 version.

There was a Crow sat chattering upon the back of a sheep;

'Well! Sirrah' says the sheep, 'You durst not ha'done this to a Dog'.

'Why I know that', says the crow, 'as well as you can tell me, for I have the wit to consider whom I have to do withall. I can be as quiet as anybody with those that are quarrelsome, and I can be as troublesome as another too, when I, meet with those that will take it.'

Hmm, a fable about those who can easily torment the weak may well find themselves cringing when it comes to the encountering the powerful.

Right then, to illustrate. What do we have here? A crow on the back of a sheep. Shall I have them in mid conversation or the crow just landing on the sheep's back? Is the crow heavy? I must exaggerate his size in order to make the sheep look more vulnerable to his harassing. What viewpoint shall I take and what eye-level? Sideways or foreshortened view? In the foreground or background? What sort of atmosphere? Do I want any distinctive light source? What expressions on their faces? Crow with a bossy frown and open beak, chiding the sheep. I'll have the sheep turning round looking reasonably benign but resigned as she looks at her tormentor. I shall have a resolute sheep not a timid one. Shall we have just the two creatures, with or without a background? I'm planning to do most of the settings where I live around Ditchling. What kind of landscape do I want for the setting? It'll be dark soon. I'd better go out and wander around the farm, a stone's throw away. Put on hat, scarf, overcoat, gloves and walk out into the countryside with paper and propelling pencil with an HB lead. If the lead is too hard it causes too much indentation into the paper and some difficulty in rubbing out when you've applied the ink. If it's too soft the paper gets mucky. I like propelling pencils because you don't have to sharpen them. The pencil work is essentially a guide for subsequent pen and ink overlay drawing. I have fixed the paper to a drawing board.

It is very cold as I trudge across the fields. The sheep have had a special feed of hay and they are all huddled together with steam coming out of their nostrils. I've already got permission to wander around the farmland. Come across one of the crumbling outbuildings. I want to draw this head-on as a backcloth to the scene. I like flatness and I like symmetry. I place myself before the building and adjust my position to get the two pollarded willows just in front of the left hand side of the building. It always fascinates me how the relationships between objects change if you move just a little. Once the position is established I start to sketch on the actual paper, which

will also be used for the finished illustration. Usually I do a rough drawing on a separate piece of paper then light-box it onto another sheet of paper for the final illustration. Today I feel optimistic since most of the visual reference I need surrounds me.

I have already measured out the drawing area – a six-inch square. In the final printing it will be slightly reduced. Square shapes are interesting to work with. They do not have a natural dynamic which rectangles possess. The square is a neutral shape. The paper is scaringly white, untouched but for its pencil boundary-lines describing the square within which I have to draw. It is cold. I am suddenly apprehensive. Where shall I start?

Oh dear, the agony and dread of making that first mark on a fresh piece of whiteness before you. When beginning a drawing, Laura Fairlie (in Wilkie Collins' novel *The Woman in White*) declared – 'Fond as I am of drawing I am so conscious of my own ignorance that I am more afraid than anxious to begin.'

Bracing up to begin then, I start with a rough sketch of the whole scene before me – knowing that eventually I will be placing the sheep and crow in a field later on. The preliminary sketch is a diagram of the proportions and features of the building. How many rows of tiles are there on the roof? How many partitions are there in the wire fence? Why do I have this desire to be accurate? What is going to be white and what is going to be black? I must have the building darkish on the left to allow for white willow trees. There is some snow on the roof in reality but none on the trees and I'm ignoring the snow, except the whiteness of the path, which might help the drawing by relieving the busy textures. Besides clarifying the existence of the fence, a white path will also act as a nice divider between building and the field.

It takes about an hour to accomplish an adequate skeleton outline drawing of the top half of the illustration – from the top of the roof to the base of the path and trees. There are plenty of sheep around and I make quick studies of their heads and feet on a separate piece of paper. How yellow their fleeces look in the snow.

Feeling that I have got what I want, I go back home. Back into the studio. Feel quite excited about the prospect of making sense of what I had drawn outside and hoping I have enough information in the pencil diagram of the scene. Continue with the pencil, clarifying what may have been left vague when drawing outside earlier. There is no real worry about the drawing at this stage. It is a slow construction of the foundations and scaffolding with the pencil prior to building the final drawing with pen and ink. If you

make a mistake in pencil at this point it is easy to rub out. There is also plenty of scope for changing tack. The pencil drawing has to be right however. If the pencil 'underdrawing' is wrong at this stage, the flaws will always show up in the final pen and ink drawing later on.

The pencil drawing of the background is now finished. And so to work on the crow and the sheep. Spend time looking up references of

sheep and crows. I have dozens of books of animals. In minutes my studio floor and desk are covered with open books showing all varieties of crows and sheep. Pile up the best references on my desk and set to drawing in pencil again. There is good reference here but they never show the creatures in the exact positions you want them. The *Saunders* 'Manual' comes in use for the crow and I mainly use one or two of the studies I made of the sheep when I was outside in the fields. It is always confidence-boosting to have lots of reference material. Each piece of reference might provide a spark of information – how the feathers of a crow are arranged, for instance, or what its talons look like.

The pencil drawing of the sheep and crow is now finished. I have placed them in the field, which I will do as a texture last thing. This is a critical moment for deciding if the image is close to what I want it to be. Now for the pen and ink drawing, hoping to complete the outline drawing of the whole composition by the end of the day. Still trying to grasp that desired but obscure image that has been half living in the head.

The pens and inkbottle are ready. I use Rotring China ink as being reliably black but smooth, at the same time not too gungy! Favourite pen nibs are Brandauer's 'Herald' pen (number 404), Gillett's Excelsior 'Legal' pen and 'College' pen. I've got several boxes of pen nibs to last the rest of my life! Indeed I have sufficient scalpel knife-blades, elastic bands, erasers, drawing pins, paper clips and pencils and other art materials to last a lifetime! I bought a ream of Kent Hollingworth paper in December 1978 and I am still using it 16 years later and there's plenty left! I also have a mapping pen and a battery of Rotring Isograph pens (13s, 18s and 35s). How I detest the endless cleaning and shaking of these Rotring pens when they don't work.

It is always scares me applying the ink onto the paper, even though I am accustomed to the paper's surface and how it absorbs the ink in the way I want it to. You have to have a sense of anticipation of how the ink is going to settle down when it has dried. This only comes from experience of knowing the paper and it idiosyncrasies well. The paper has to be as right as soil is to plants. What surface you draw on is as important as what implement you draw with. Different inks and paints have different reactions and you have to be ready for these.

Now to set the vague vision into concrete form with the black ink. This is the frightening bit – the bit I dread. I've established the idea and composition of the illustration in pencil. *Now* is the critical moment when you have to decide if the pencil drawing shows you something that is worth proceeding with. So often it is the *rough* that has the real energy whereas the finished illustration seems to be a sanitised version of that rough.

I start by drawing a very thin outline of the composition in ink, going round the edges of the main forms. Doing this is quite stressful. There's no going back and if I make a mistake I will have to start the

process all over again. Every time I start to embark upon a picture I always feel as if I'm a novice. It is slow and deliberate work and makes me feel tense as I draw over the pencil drawing with my pen nib. I find I am holding my breath for ages dreading the drawing going wrong. Sometimes I actually get dizzy from lack of oxygen. I also grit my teeth too tightly. Picture making is such an intense occupation. Why is it so? Is it for others too? Of course it is. Why do we do it? What is it that compels us to make pictures? It has been such a part of my life for so long now that I seem to live through making pictures. I don't mean earning a living, I mean living a life through the countless hours of picture making. Sometimes during a day I may have spent more time looking at pictures on my desk (and looking at students' pictures, when I used to teach) than looking at 'real life'. Even when I am looking at the *real* world my fingers twitch as if I am making a drawing of it in my mind.

It is a world of its own when you are *making* a picture. It is that creation of a new world by drawing on a piece of blank paper that is irresistible. It is the thrill of the unexpected. Although you authorise what you do – it is the surprises that occur when making an image that hold your interest. As if something else is controlling you when you are drawing. Like all forms of travel, the journey of doing a drawing seems to be full of hazards. The image seems to be a vast landscape of a world that you are inventing and when involved in it you are drawing well beyond the confinement of the piece of paper and deeper than its flatness. Suddenly you are brought to a jolt when you look at the picture after an interval of being away from it. It no longer seems to have the intensity it possessed when you were drawing it. It becomes flat and ordinary. It becomes a *drawing* instead of a world. Then as you return to carry on with the drawing it becomes another world again. I think it is this fascination that compels me to do it. It is trying to get it right, which I never do, but I may do one day.

At last the initial pen and ink outline is complete and all has gone reasonably well so far. It is good to get away from a drawing that you've spent a long time with but during supper, and just before I go to bed, I find myself popping into the studio now and again to have another peep at it.

Second day: Today the picture no longer seems to resemble the mirage, which had been lurking inside the brain yesterday. The hopes of yesterday seem to be commonplace today. The picture is now beginning to be a real thing and the reality is becoming a disappointment. Overnight it seems to have taken on a banal look. The complexities and struggle of getting the composition and all its contents together yesterday now no longer seem to be evident in the outline drawing which now sits before me on the desk. Final rendering will hopefully bring back some magic.

Back to scratching away the hours with pen strokes and cross hatches.

Music in the background interspersed with radio programmes. Now the illustration seems to be taking on its own spontaneous life as each stroke of the pen tries to determine the next mark. Then another flurry of stumbling and adjustments. The independent life of the picture has steadily unfolded itself and it prompts me to make unexpected and spontaneous drawing decisions on the spur of the moment. This is walking a tightrope and the picture itself seems to be in control rather than me. I am still holding my breath too much. The murky impression of what was initially hoped for is no longer a consideration now. New forces are at work. The control is lost. A different picture to what I expected is emerging. Some of the previously laid conceptual plans are now abandoned as new forces are at work during the experience of making the drawing itself. It is then a struggle, as unexpected adjustments have to be made in the light of seeing the drawing emerge as an entity before your eyes. The resultant illustration is a reconciliation between control on the one hand and lack of control on the other. I daren't question the way the drawing is going in case I stop it in its tracks. A degree of detachment is necessary in order to let the drawing survive. I hope for the luck of happy accidents. Drawing 'well' seems to come from the heavens as much as from experience and hard work. I am tense one moment and relaxed the next. The heart is beating. Sirens are singing in my ears and my head feels like crunched cotton wool. I look at the illustration and I look at it again. I look outside the window and look at the illustration once more. I look at it close to, and I look at it from a distance. I need to get away from it. Have a break. Lunch with Raymond and Denie in a local pub. They don't seem to be real. The illustration is more real and is still sizzling inside my head. I cannot concentrate on what they are talking about.

Back home and back to the drawing. Absence from the picture has made the heart grow fonder. Now to tackle the intricacy of the barbed wire and the white willow branches. Loved doing the scratching on the white part of the building on the right. Decided not to square off the top part of the drawing. And then on to the monotony of the grass. Sheep and crow now done. Securing the creatures' mutual staring of one another and getting that half-smile on the sheep's face was difficult. Strange how drawing becomes a completely abstract involvement – making abstract patterns to conjure up a reality. The awareness of drawing an actual crow, a sheep, a tree or a building recedes during one's involvement in the drawing. All pictures are abstract.

Oh dear, the sheep's hooves are not really sinking into the grass nor are they partly obscured by it which they should be. Must change this later. I wish I'd got the crow's claws sinking into the fleece more. As a final gesture I perpetrate some wiggly lines upon the fleece of the sheep as a joke against those who charge my drawing as being too tight.

How I hate to hear to those arty teachers urging students in the life-

drawing class, saying, 'Come on, loosen up and *experiment*' when 'tightening up' might be just as experimental. Experimenting is not just a matter of adopting a loose style of drawing or making a sloshy image (nor a tight one for that matter). It is essentially a matter of having ideas *inside* the image, whichever way it might be drawn. There are those who tend to take a narrow view that it is only the freely drawn and soft-edged and varied line that possesses so-called 'experimental qualities' or that special property called 'expression' in drawing. Whereas I agree that the freely drawn line does carry with it a particular type of expression (which I also happen to like myself), I do not believe that such drawing claims exclusive rights to the communication of feelings or to experimentation.

Well, the drawing is finished. But why? How do I know it is finished? Knowing when to stop is a curiously instinctive decision. It comes to a halt all of a sudden when least expected, as if it tells you itself to stop. I am too close to the drawing to see it anymore. I hardly need to use any process white to clean up any obvious mistakes. Its flaws and mistakes will no doubt stare out at me like a sore thumb when I look at it some time later. When I look at it now it is not so much as what I had in mind but more to do with what the drawing itself tells me about its own mind. If I think about it too much now I will probably tear it up and do another one. Perhaps it might ripen with age. Going on to the next illustration will relieve the anxiety of having finished this one. After all, finishing one picture is only a stepping-stone to the next one.

Pour out a scotch and ginger and relax with utter content to a Haydn Symphony. This time I listen to the music properly. Three illustrations completed, 107 more to go! Meanwhile the radio news tells us that the pound fell below one dollar ten cents and in West Germany seventeen RAF bandsmen are among nineteen killed when their bus collided with a petrol tanker near Munich.

Glad the drawing hasn't been consigned to the wastepaper basket yet. I only hope these first Aesop illustrations mark a slight change in my work. It is more and more difficult to be satisfied with what I have done the older I get. I do find illustrating to be more exacting as my sights get higher and unattainable (and my sight gets worse!). I am so rarely happy with what I've done these days. I ponder upon the question of becoming an older illustrator. I have been illustrating for over forty years now and one of the big challenges is to try and climb out of one's own habits. There is a danger of repeating yourself in the illustrations you produce. There is nothing worse than producing illustrations when the

final results are entirely what you expected. It can be stifling if you anticipate too much what is going to happen to an illustration when you are in the process of creating it. A certain lack of control and the willingness to allow sparks of intuition to enter the picture-making process can take you on an adventure of unpredictable directions – and this keeps the whole activity alive. For me the real fun I get out of

making pictures is never *quite* knowing what is going to happen next. It is the reason why I keep on doing it. Oh dear, I forgot to draw the grass round those hooves, drat it!

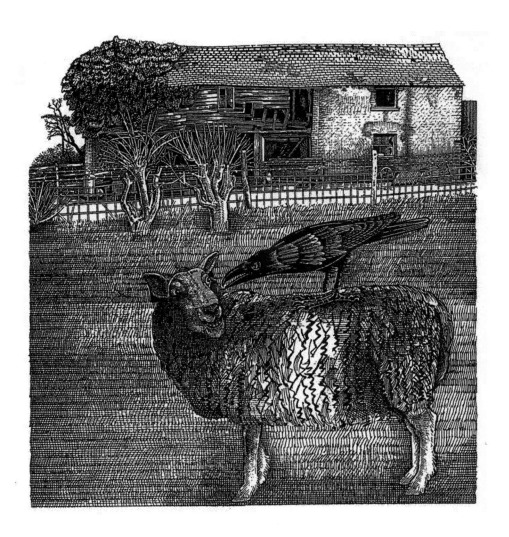

JULIAN BURTON

I am an artist and visual facilitator, working in organisations, providing a visual dimension to meetings and workshops. I provide a graphic perspective on important issues in meetings; before, during and after. My main skills are listening, synthesising and visualising concepts; developing visual symbols, metaphors and narratives that stimulate constructive discussion on complex strategic issues.

My work can:

- Capture the ideas, meanings, concern and issues expressed in meetings, reflecting them back visually, as a catalyst for further discussion.

- Provide a visual overview of a current situation,expressing and conveying complex inter-related issues in context symbolically.

- Engage a group's attention and enable it to grasp quickly the main issues and focus relevant elements.

- Structure problems to facilitate shared sensemaking, developing novel perspectives that can open up new possibilities in meetings.

Visual Diologue:

Drawing Out 'The Big Picture' to Communicate Strategy and Vision in Organisations

'My dad draws pictures of problems so people can talk about them.' Oliver Burton.

Drawing – to depict or represent in lines with a pencil on paper

Process – a series of action which produce a change or development

Communication – to impart knowledge or exchange thoughts by speech, gesture or symbol, which creates or maintains relationships that have mutual, sympathetic understanding. To make or have human connection by sharing common beliefs.

Introduction

I am an artist and management consultant and this paper is about how I use the process of drawing pictures to improve the communication of vision and strategy in organisations. I will explain the context I work in, the process I have developed called Visual Dialogue, and how it works, and give an example of a recent successful client project.

An organisation is a large group of people who co-ordinate their activities for a common purpose and mutual benefit. The social co-ordination is managed by using mainly verbal symbols, spoken and written. How successful any communication is depends not only on the content and quality of the message, but equally on the sensitivity of the response. The meaning of a message lies in the response and clarity of meaning and is a result of mutual interpretation which can only really be negotiated, in my opinion, in face to face conversation.

The Problem

Good communication is the vital process that binds people together into successful organisations but owing to increasingly complex pressures and demands it is becoming harder for leaders and managers to communicate strategy and vision in a way that effectively engages and motivates a workforce. I believe that the main reason for this is that a significant amount of formal communications are one way and consequently become meaningless jargon for the recipients. Strategies, targets or directives are given out with little opportunity for people to respond honestly, and there is little time or space for the informal conversations where people normally negotiate the meaning of what they are doing and make sense of what is being asked for. This creates a situation of uncertainty, confusion and stress as people try to do their job without being able to come to their own conclusions about what they need to do and how to do it. The lack of clarity in meaning is becoming a huge challenge for leaders, as it creates low morale,

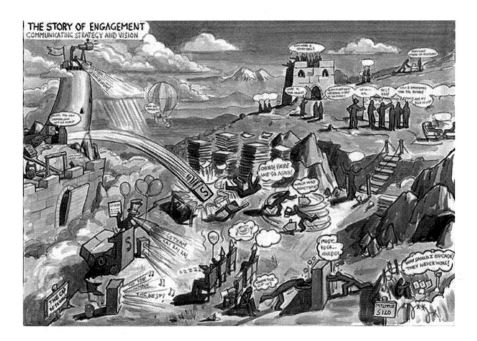

disengagement and consequently poor performance.

Successful communication in today's organisations is vital to the delivery of better service. It is the key to unlocking commitment and creating the trust needed to improve performance. Good communication is at the very heart of effective team work, the glue that binds people together in achieving common objectives. Yet understanding how that binding happens and creating it is one of the biggest challenges facing leaders today.

Visual Dialogue

Visual Dialogue is a leadership communication tool that supports the vision and strategy process in a highly creative way. It uses pictures, metaphors and stories as powerful catalysts for discussing the challenging and complex changes which organisations must negotiate successfully. The communication of strategy and vision can be facilitated by using pictures to stimulate constructive and meaningful dialogue. Pictures can provoke new conversations and interpretations, promoting better understanding which enhances working relations and consequently performance.

At its core Visual Dialogue is a process to help leaders create their 'Big Picture'. This gives them a useful tool to explain it to their team in a way that really engages and involves them in its evolution. It can then be used to give the whole organisation the Big Picture, helping

people to understand their part in it, so everyone is working to a common purpose. The core benefit is, simply, that it promotes good communication throughout an organisation. This process maps out the journey of the organisation, making a 'Big Picture' of the story that a leader wants to tell. It is an engaging way to start a conversation.

Drawing out 'The Big Picture':

- captures many key strategic themes in one story, helping you to put across complex ideas in a simple and powerful way
- enables teams to get a grip on complex and difficult situations, bringing them together on common ground
- focuses a group's attention on crucial issues and challenges, stimulating creative solutions
- creates a reflective space where people engage in open, honest and constructive dialogue
- engages the emotional and the rational, bringing more resources to the table
- gives a tangible and memorable artifact that anchors new insights for effective learning
- provides a message that is cascadable in a new and dynamic way

Applications

One use for this method is to help teams agree on a common perspective. A team is interviewed, and a picture is drawn that distils many aspects of the organisation's current reality that are not usually discussed openly. It is then used to engage them in conversation. Usually it allows discussion on difficult subjects, as the picture, often containing humorous details, becomes a focus of attention creating a safe space to voice concerns and ask burning questions.

Another application is as a bridge between team development and internal communication. From initial interviews with a team leader, a 'Big Picture' emerges that is used personally by him to communicate his vision/strategy/values to his teams, engaging them in a rich and insightful discussion. The picture is then evolved and developed to be taken into the organisation to engage everyone in discussion, moving the dialogue forward in a constructive and creative way. In short, this method catalyses rich, informal and meaningful dialogue.

This method unlocks the power of the visual senses, tapping into the more intuitive, aesthetic and emotional ways of understanding that

perfectly complements the rational, logical and linear ways that are currently used in organisational change. Drawing pictures is a simple and effective method to stimulate focused discussion in small groups by drawing out people's images and visual metaphors in conversation with them. This cuts through jargon, validates experience and concerns currently engaging their attention.

Using large pictures in small groups helps to focus attention on crucial issues and challenges. Drawing out what emerges in discussion tangibly anchors new insights and shared meanings, helping to create common ground for client teams. This process supports leadership team development, culture change and strategic communication projects. Creating large and colourful paintings of shared visions, strategies and change issues creates a reflective space to really engage in open, honest and constructive dialogue.

Graphic Facilitation

The first step in the process is graphic facilitation. This means that in a strategy meeting or workshop the ideas and themes that emerge in discussion are immediately drawn up in pictures and words on large sheets of paper displayed on the walls around the room for all participants to see and reflect on as they discuss agenda items. People can see what they have said and that they have been heard. Seeing what you are talking about translated into tangible, visible form can really focus attention on important issues, anchor new meanings and help to give you and your team an immediate grasp of 'the Big Picture' in a way that is unavailable by words alone. This approach enriches the work of the group and enhances its ability to focus and create shared understanding. This technique creates added value during the meeting itself, and the pictures made are used afterwards as a record or group memory of the main themes.

Example

'How can we improve performance?' – Using Visual Dialogue to facilitate shared meaning at a large conference. By capturing the essence of key issues with pictures to stimulate constructive discussion

Recently I was engaged by the NHS as a visual facilitator. The occasion was a conference that was essentially a forum for sharing stories of successes that had occurred since the introduction of the most recent NHS Modernisation Plan. Six hundred managers and staff attended. I was asked to create a picture that would capture the essence of such success, as a vehicle for reflection and celebration of the experiences of those involved.

The style of the conference was similar to a knowledge fair; a large informal space filled with booths and displays of various initiatives and projects about

recent innovation in health care delivery. Participants were free to choose to whom they talked and what they talked about. I was positioned in a booth, available to draw and interview anyone who happened by.

Some passersby were attracted to the pictures I was sketching from the first informal conversations that took place. I acted as facilitator, asking participants to share their experiences, which I immediately drew up on a large piece of paper. As a picture took shape it became a catalyst for further dialogue. (My line of questioning was in the style of Appreciative Inquiry, tapping into what motivates people.)

It soon became apparent that many participants had insufficient information about how well their unit, trust, or facility was performing. Consequently, they were finding it difficult to recognize and define success.

As this theme developed, it evolved into further discussions with other participants on how to improve feedback mechanisms to provide staff with a clearer and more meaningful assessment of the quality of their unit's performance.

The main insight to come out of the informal discussions I facilitated was that informal feedback from close colleagues is the most beneficial for personal learning, innovation and performance enhancement...'its nice to be told you made a difference. I always feel valued and appreciated and it gives me more meaning at work'... 'Informal feedback? We all need it, and actively seek it out'...'Formal feedback mechanisms don't seem to reflect the hard work I do!'

I captured the day's discussion in a large, colour picture that we used a few weeks later during a review of the event. The visual output was used to focus and generate further discussion by engaging the review group's attention. Group members were thus able to quickly grasp the main issues and focus on relevant elements.

Such an exercise demonstrates how visually structuring complex and difficult issues can provide a space in which fresh perspectives can emerge that allow groups to see things in a new light.

One great advantage of visualising the themes that emerge is that an image can be a powerful focusing aid. Images help people to quickly grasp the core material and concentrate on relevant issues, providing symbolic encapsulation of complex and difficult concepts.

Visual dialogue is a valuable tool for enriching the quality of any group discussion, capturing themes in a way that keeps the conversation moving. The result, almost inevitably, is a more useful outcome.

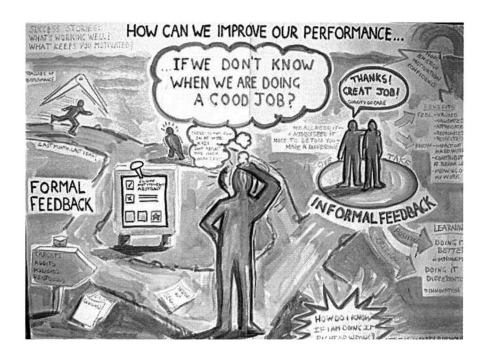

KEVIN FLYNN

Kevin Flynn studied under the direction of Françoise Henri at University College Dublin as Purser Griffiths Scholar, with the Lewes Group of Romanesque Wall-paintings as the topic for his M.A. thesis; following a period as research assistant at the National Gallery of Ireland he undertook a study of the relationship between Anglo-Saxon and Romanesque illumination and wall-paintings at the Barber Institute, undertaking there an M.Litt. thesis dealing with this subject as it concerns English Art of the period.

Since then he has held a variety of teaching posts, culminating in his current position at the Arts Institute of Bournemouth where he teaches Theory and Contextual Studies on a variety of courses while publishing in his specialist field. Current research interests include questions of stylistic and interpretative development of the Winchester School of painters (with a paper pending on the muralists at Kempley, Glos.), the development of electronic teaching packages for students of both F.E. and H.E., and in particular the nature of published British illustration of all forms from the last quarter of the twentieth century.

He has held a series of one-man shows of landscape-paintings of the south coast and the woodlands of Dorset and Hampshire, with work in progress entailing studies of the Isle of Purbeck.

 The Beginnings of Drawing in England

As Roman life and order gradually fell away from Britain, the Anglo-Saxons took over the lowlands until a steady pagan settlement covered much of what was to become England. The reintroduction of Christianity at the end of the sixth century, and its establishment in all the royal Anglo-Saxon courts by the end of the seventh century, led to a flourishing growth of book production. The papyrus roll of the ancient world had given way to the codex with its rectilinear parchment or vellum pages offering the kind of clear-cut visual frame that Insular and Anglo-Saxon artists relished; stone, wood, metal and ivory had already provided manageable surfaces for the decorative and sometimes narrative line, but the ease of working with metal-point or quill or reed pen on a smooth receptive surface prompted a super-abundance of decorative energy. Books were primarily the carriers of text, of words; and the scribe, no longer the slave of the Roman world, began to find ways of demonstrating the sacred quality of the word as sent by God in the Gospels and service books.

First moves included the magnification of significant initials, linking them to the body of the text by a gradual diminution of adjoining letters. Such prominent initials then grew spirals, dots, curves and fins, and here and there an animal head (e.g. The seventh century *Cathach of St.Columba*) (Dublin Royal Irish Academy S.n.).[1]

Such expressive decoration was rapidly followed by the incorporation of the decorative vocabulary of the portable arts – interlace, strapwork, trumpet, spiral, guilloche, fret, and step. Carpet-pages, jam-packed from edge to edge with intricate and minutely draughted patterning began to confront the opening initial of each Gospel, initials which in turn grew beyond alphabetical representation to become a divinely-inspired visible shout. Typical examples range from those of the *Book of Durrow* (Dublin Trinity College MS A 4.5) and the Lindisfarne Gospels (London, British Library MS Nero D IV) to their culmination in the *Book of Kells* (Dublin, Trinity College MS A 1.6). The illuminated pages of the latter are filled with 'intricacies so delicate and subtle, so exact and compact, so full of knots and links, with colours so fresh and vivid that you might say all this was the work of an angel and not a man'.[2] Here zoomorphic forms strain against their geometric confines, benign and or fey faces surface between metallic patterning, and cats and mice, cocks and hens, rabbits, dogs, and fish wander in and out to link the pages with the illustrator's own physical world.

Parallel with this largely abstract insular decoration came Mediterranean influences, to be found most obviously in the creation of evangelist portraits, now full-page instead of being held in the papyrus roll medallion. Some early examples show insular artists adapting continental models to their own stylstic approaches (e.g. *St. Mathew, f.25 Lindisfarne Gospels*), others assimilate classical formulae with ease, adapting these while developing an eye for some forms of naturalism (e.g. *f.150v.* of the Canterbury *Codex Aureus*, Stockholm, Kungliga Biblioteket A135).

Viking incursions not only stopped the making of these books but also ensured the destruction of many earlier works, and not until King Alfred's reign gave political stability and deliberately encouraged the resurgence of creativity did drawing *per se* come into its own. This is not readily apparent in the first known English presentation page (*King Athelstan offering a book to St. Cuthbert*, f.1v of Cambridge, Corpus Christi College MS 183), which includes a game attempt at Carolignian rising perspective, while still echoing the stolidity of the figures on St.Cuthbert's Stole (Durham Cathedral ca. 909); but it is very evident in the first of an evolving series of full-page figure drawings. The first of these latter is by St. Dunstan, a man famed for the quality his painting and calligraphy; at the beginning of his *Classbook* (Oxford Bodleian library MS Auct.F.4 32) he drew, in a firm brown ink outline, a three-quarter length figure of Christ as the *Wisdom of God* (f.1). Perhaps ultimately derived from a Carolignian ivory, it has its own approach to form, and careful observation is reflected in the convincing hands and wrist and forearm, as well as the weighty balance of the head. It is an example of Wormald's 'first style',3 a style taken to a freer translation in a full-length brown ink figure drawing of a youthful Christ running the length of a page and surrounded on all sides by the text into which He has been inserted (Oxford, St. John's College MS 28 f.2). It is a piece of graphic design which retains its monumental serenity within the screen of words, as weighty as the previous example and now planted on two solid feet, having somewhat livelier drapery. St. Augustine's Canterbury also produced a full-page drawing of Boethius' *Philosophy* (Cambridge, Trinity College MS 0.3.7), a study in deliberate interpretation of the author's words: 'a woman... having a grave countenance, shining, with clear eyes and sharper sight than is usually accorded by Nature'. The body is lost in this case, however, behind the formalised drapery. The calm and self-assured quality of these drawings, designed to evoke reverence, and in the case of philosophy awe, is given an increased vivacity in a late tenth century drawing from St. Augustine's of David on f.1v. of a Psalter (Cambridge, Corpus Christi College MS 411). This liveliness is shared with another St. Augustine drawing (London, Lambeth Palace Library MS 200 (part II) f.68v) encompassing a group composition in which St. Aldhelm presents his book to the Abbess of Barking and eight of the nine nuns named in the dedication written above the group. The movement of the drapery intensifies the emotional importance of the event as the concerted looks, inclined necks and fixed gazes of the nuns add to the expressive quality of the hands and the jostling of the small plinths on which they stand.

At Winchester the late tenth century saw the introduction of colour variation in the drawing line, e.g. in an image of *Christ on the Cross* outlined in brown with the addition of red and blue, and, significantly, with the added element of broken lines and marks creating His head, and the figures of Mary and St. John beside Him (London BL MS Harley 2904 f.3v). The illustrator involved put this freer fragmented line to further use in his drawings of the constellations in an edition of the *Phaenomena* of Aratus of Soli

(London B.L. MS Harley 2506); his Cetus Figure 1 f.42) is a baggy, grumpy seamonster (from whom Perseus has rescued Andromeda) defined by quivering broken lines, his failing muscles, pouchy skin, and lolling tongue an expression of the artist's vivid imagination rather than any record from the night sky, drawn using both pen and brush. Some scriptural and service books undertook an approach whereby leafy foliate frames held figures saturated with colour, while other texts had begun to make good use of drawing in its own right, without the expense of time and pigment found in costly illumination. Such is the case with the late tenth century *Psychomachia* of Prudentius (Cambridge, Corpus Christi College MS 23). The drawings here, in a variety of coloured lines put in with brush and pen, span the width of the page with busy animation, the figures twisting and gesturing, their faces in profile or three-quarter turn. Their energy and verve, as with so many English examples in the early eleventh century, owe a lot to a single manuscript of c.820 imported into England by the end of the tenth century – the Utrecht Psalter (Utrecht, University Library MS Script.cccl.484), which provided extensive narrative drawing in parallel with, and simultaneously illustrating, the text. In England this Psalter's monochrome lines were refashioned with those of red, green, blue and sepia inks in the first of three new editions (London BL MS Harley 603). These lines 'though sometimes departing in varying degrees from the composition and style of the original, preserve a great deal of the tense vitality, intimacy and vibrant sketchiness of outline of the Utrecht drawings, while the extremely active attenuated figures with dramatic gestures and wildly agitated draperies become a feature of later Anglo-Saxon illumination".4

The *Utrecht Psalter* or Rheims style permeates the drawings of the artist of the second part of the *Caedmon* Anglo-Saxon paraphrase (Oxford Bodleian Library MS Junius II (S.C. 5123) with all their impetuous and rapid calligraphic energy of execution. They make something of a contrast in scale and much else with the more calmly paced and roomier full-page compositions drawn by a colleague working on the *Genesis* folios; these latter in turn find their liking for architectural settings and landscapes put to good use in an early eleventh century *Calendar* from Christchurch, Canterbury (London BL MS Cotton Julius AVI). This is the first English calendar to show the occupations of the months, and in so doing betrays the artist's relish for his subject; as well as providing careful technical drawing of e.g. the logger's cart (f.5v), the illustrator conveys a sense of place and occasion rooted in observation and enjoyment. The middle of the century saw the same subject less ably handled, with the lightness of touch of the Canterbury drawings

swamped by flat colour set in solid outlines (London B.L. MS Cotton Julius A.VI ff. 2-17). Folios 32v.-49v of the same manuscript have a series of drawings to accompany Cicero's translation of this further version of the *Aratea*; their rendering of the constellations reverts to setting them within the body of the text, the words lapping the outline of e.g. *Perseus* (f.34) in order to create another enlivened if

not readily legible piece of graphic design. Other artists chose to direct their drawings up and around text in light lines which, while lesser in weight than the script, manage to suggest a sense of depth of recession in which people and angels can move convincingly, e.g. The *Bury Psalter* (Rome Vatican Biblioteca Apostolica MS Reg.lat.12,. f.73v).

Just prior to the Norman Conquest an artist at Winchester produced 16 full-page drawings for a psalter (London B.L.MS Cotton Tiberius CVI), drawings which, while somewhat old-fashioned in their mannerisms, remain both expressive (Ronald Searle's depiction of Grabber, head boy at St. Custards, finds his ancestry here on f8v) and, more importantly, are fully capable of moving the eye across the page or double page in chronologically logical sequencing of the narrative.

Many herbals, leechbooks, and other scientific texts survived the Anglo-Saxon and post-conquest eras, being added to as new knowledge came to hand; thus a herbal spanning three centuries contains late Anglo-Saxon diagnostic drawings of the Common Teazle and Yellow Bugle (BL Cotton MS Vitellius CIII f.163), while in MS Cotton Tiberius BV pt. I we find a map of the world with an almost recognisable British Isles (f.65v) as well as a series of *Marvels of the East* including giant snakes and a somewhat self-conscious Centaur (f.82v).

The narrative skill seen throughout Anglo-Saxon illustration came into its own in Bishop Odo's famous piece of Norman propaganda, the *Bayeux Tapestry*. Drawn in eight differently coloured wools, it employs every possible device with which to make fully clear the significance of the politically correct version of then recent history – buildings have cut-away sections, viewpoints change levels, looks and fingers point out the direction to be taken if we are to catch the next scene before the ships are launched – and the once all-important text is now a series of supplementary captions. The narrow upper and lower registers hold less formal and more immediately assimilable incidents, and as a whole the work announces a potential for elaborate narrative schemes with little or no reliance on text, schemes ideally suited to the great blank walls of the new Romanesque interiors.

The Normans brought with them the means to support sustained patronage at an increasing number of royal and ecclesiastical centres; one such which developed in its artists a particular way of seeing was that of Winchester; the Anglo-Saxon tradition there had been singularly fruitful in a series of rich linear styles, and a monumental version of one of the more staid of these is seen in the head and hand on a stone set in the wall of the New Minster at some point before its 903 consecration.[5]

More importantly, Winchester in the twelfth century saw a flowering of book-illustration and murals which far surpass in quality any other European work of the period. It is possible to single out there particular painters, tracing their progress from artistic connections

with St. Albans to residence at Winchester and professional visits to the continent. The year 1148 saw the painters Roger, Pagan, Richard, Henry and William living just outside the priory gates, while in 1178 Reginald was working on decorations in the royal castle on the hill above, and at the start of the thirteenth century Luke was buying and renting land in Winchester with money earned by his painting of local churches.[6] Two painters, possibly two of the small colony outside the gates, arrived mid-century following their highly successful illustrated edition of the *Comedies* of Terence (Oxford, Bodleian Lib.Auct.F.2.13) for St. Albans, wherein their drawings (Figure 2) developed even further and with much exuberance the mannered masks and poses of the actors in the Caroligian manuscript they were interpreting (i.e. Paris Bibl.Nat.Lat.7899, itself based on a late fifth century classical text.[7] The energy and novelty of their work may have made them ideal contenders for the patronage of Winchester's bishop, Henry of Blois. Brother to the king, Henry was famed for his collector's eye. He commissioned some 38 full-page coloured drawings from the two illustrators for the Winchester Psalter (London, B.L.Cotton Nero C IV in which much of the original pigment has gone, perhaps for reuse).[8] They appear to have been given a free hand as to interpreting both iconography and style, so that the element of caricature which they achieved in such readily guyed figures as the executioner (Figure 3) in the *Flagellation* (f.21). is very marked, in this specific example drawing upon the expressive potential of the Terence masks. They also managed to replace the hieratic and distancing treatment of earlier artists with a more naturalistic if simplified understanding of such figures as Mary (Figure 4) set in the curling branches of the *Jesse Tree* (f.9).

Their reputation established, the pair next undertook part of the direction of the great *Winchester Bible*, still held in the Cathedral Library.[9] For the decoration of the two volumes of this vast undertaking (some fifty-one large and elaborate historiated initials as well as a series of full-page narratives), more than two artists were required. The two *Psalter* illustrators, therefore, while drawing and illuminating their own specific designs for the Bible, also made detailed drawings which others painted or which were left unpainted. Two complete sheets of such drawings, for Judith (f.331v.) and Maccabees(f.350v.) were kept unpainted; their subject prompted Walter Oakeshott to christen their creator the Master of the Apocrypha Drawings. These sheets are drawn upon with great skill and confidence; their fine long unerring lines create animals, figures and buildings in carefully structured and complicated compositions. They convey both calm and intense emotion in a rhythm of active movement alternating with visual rests. It would have been very difficult to have bettered them with the addition of colour.

The second of the two, Oakeshott's Master of the Leaping Figures, experimented with his preparatory drawings, allowing them a delicacy of insight denied his illuminations. This sensitivity may be clearly seen if Master of the Leaping Figure's *Wisdom* (Figure 5) on f. 278v of the Bible is compared with the Mary in the *Psalter* (f.9)

mentioned above; either the first is a direct reworking of the second, or both are developed from the same exemplar or model book.

Work on the Bible was abandoned, perhaps because of its premature presentation by Henry II to his new foundation of Witham in 1179. The foremost of the generation of Bible artists following on from the Apocrypha and Leaping Figure Masters was Oakeshott's Master of the Morgan Leaf, so-called after the museum which houses a sheet of his illuminations, illuminations superimposed on further drawings by the Apocrypha Master (New York, Pierpont Morgan Library MS 619). The Master of the Morgan Leaf, fully aware of the classical forms underlying the newly all-pervading influence of Byzantine art, had outgrown his teachers; at Winchester his first monumental scheme was the earlier of two *Deposition* and *Entombment* compositions in the Cathedral's Holy Sepulchre Chapel, a small Easter Sepulchre set between the northern piers of the central tower. The composition is based partly on a design by the Apocrypha Master and retains the rather tight structuring and strong black defining lines of a manuscript illumination while reaching out to a new and strongly modelled naturalism. A more exacting commission, after a probable visit to the Byzantine mosaic schemes of Sicily, was that of the large-scale narratives for the Chapter House of the Queen's Convent at Sigena (Huesca) in Spain in the early 1180s, lost in the fire of 1936.[10] Here naturalism and a rhythmical gravity move further away from the early expressiveness of e.g. the *Winchester Psalter*; yet even in Spain initial stylistic impulses must out, and the distinctive face type of the Terence mask, developed into the Psalter executioner's figure-of-eight shaped mouth, flaring nostrils and rat's tail beard (Figures 2,3), is redrawn as the head of a lion (Figure 6) on the walls of S. Pedro de Arlanza.[11] Here again it is tempting to surmise the use of an artist's model book with its early pages begun at St. Albans.

Some twenty years later, once more in Winchester, an ageing Master of the Morgan Leaf undertook to repaint the Holy Sepulchre Chapel, partly, no doubt, for aesthetic reasons, but essentially because its flat wooden roof was being replaced by a fashionable arched vault which cut into the original scheme. Much of this later version is little more than a sinopia under-drawing, the surface skimmed by time, and the quiet dignity of his Spanish material, well-suited to its setting, is exchanged by the Morgan Master for something of the older Winchester expressiveness, but with a compassionate emotionalism in his swaying figures. Such a stylistic evolution is logical enough in a long career , although here too is evidence of the modelbook put to use – Longinus (Figure 7), with his fierce and anguished profile and gesturing hand, is a magnified mirror-image of one of Absalom's mourners (lowest register, Morgan Leaf verso (Figure 8)), in turn derived from the *Psalter* and used again at Sigena.[12]

A similar instance of two illustrators creating monumental narratives occurred at Canterbury ca.1150, in St. Gabriel's Chapel in the Cathedral crypt, and here too sinopia drawings remain clearly visible

and readily comparable with their work in the two volumes of the *Dover Bible* (Cambridge Corpus Christi College MSS 3+4). The older artist, working on the second volume, represents a local pictorial tradition which delighted in stylisation – spectacled eye-shadows, nested folds to drapery, elaborately and very accurately drawn key-patterns (Figure 9). His colleague acted as a conductor to the new byzantine naturalism in the first volume, and the pair of them (Figure 10) are pictured at work on f.241v of MS4, one of them perhaps the painter Alberius who held Canterbury land from 1153–67. Together they made drawing and painting in the crypt on an extensive scale; and as at Winchester the latter is always confident and rarely corrected.[13]

It is from Canterbury that comes one of the very few purely practical drawings of the period, ca. 1160, a plan of the monastic buildings recording the water supply and drainage system, depicting pure water brought in from local springs to irrigate wheat, vines, and orchards as well to sweeten the fishpond and to provide drinking water; and water collected from the roofs for the lavatories and to flush the drains.

The English proto-Renaissance, which encompassed the naturalism of the Winchester School and the work at Canterbury, Durham, and other centres, lasted little beyond 1200. Gothic architecture did away with the large blank walls so suited to narrative schemes, replacing them with stained-glass windows. In these the leaded lines dictated a highly decorative approach, one in which courtly elegance was to edge out realism and gravitas, and in turn drawing itself fell prey to the same fashionable taste.

[1] For the evolution of the initial see C. Nordenfalk. *Celtic and Anglo-Saxon Painting in the British Isles 600-800.* New York: Chatto & Windus, 1976.

[2] Giraldus Cambriensis, quoted in J.J.G. Alexander. *Insular Manuscripts from the 6th to the 9th Century.* London: Harvey Miller, 1978, p. 73. For an exhaustive account of the Book of Kells, see F. Henry. *The Book of Kells.* London: Thames and Hudson, 1974.

[3] For an analysis of the styles in question, see F. Wormald, *English Drawing of the 10th & 11th Centuries.* London: 1952.

[4] E. Temple, *Anglo-Saxon Manuscripts.* London: Harvey Miller, 1976, p. 82.

[5] F. Wormald, and M. Biddle, *Antiquaries Journal* XLVII, 1976, pp. 159, 162, 277.

[6] Recorded in the Winton Book Record Commission *Domesday Book IV* addimenta 531-62; and M. Biddle, O. Von Feilitzer, and D. Keane, *Winchester in the Early Middle Ages.* Oxford: 1976, p. 72 et al.

[7] C.M. Kauffmann, *Romanesque Manuscripts.* London: Harvey Miller, 1975, p. 102.

8 N. Riall, *Henry of Blois, Bishop of Winchester, A Patron of the Twelfth Century Renaissance*, 1994.

Hampshire Papers (5). F. Wormald, *The Winchester Psalter*. London: Harvey Miller, 1976.

K. Harvey, *The Winchester Psalter– an Iconographic Study*. Leicester: Leicester University Press, 1986.

9 W. Oakeshott, *The Two Winchester Bibles*. Oxford: The Clarendon Press.

C. Donovan, *The Winchester Bible*, Winchester: Winchester Cathedral, 1993.

10 W. Oakeshott, *Sigena – Romanesque Painting in Spain and the Winchester Bible Artists*. London: Harvey Miller & Medcalf, 1972.

11 O. Demus, *Romanesque Mural Painting*, London: Thames and Hudson, 1970, p. 487.

12 For an alternative interpretation see D. Park, *The Wall Paintings of the Holy Sepulchre Chapel*, 1983. BAA Conference VI 1980. pp. 38-62.

13 K. Flynn, *Romanesque Wall-Painting in the Cathedral Church of Christchurch Canterbury*, 1979. Archaeologia Cantiana XCV, pp. 185-195.

Figures

1 Cetus the seamonster, BL MS Harley 2506 f.42

2 Symo, Comedies of Terence, Bod.Lib.Auct.F.2.13. f.16.

3 Head of Executioner, Winchester Psalter BL Cotton Nero C IV f.21.

4 Mary in Jesse Tree, Winchester Psalter BL Cotton Nero CIV f.9.

5 Wisdom , Winchester Bible, Cathedral Library, f.278v.

6 Head of lion from S. Pedro de Arlanza , The Cloisters, Metropolitan Museum, New York.

7 Longinus, Holy Sepulchre Chapel, Winchester Cathedral.

8 One of Absalom's mourners, Morgan Leaf, NY Morgan Library MS 619.

9 Key Pattern, Dover Bible, Cambridge Corpus Christi College MS 4.

10 The Illustrators of the Dover Bible, f.241v. of Cambridge Corpus Christi College MS 4.

Figure 1. Cetus The Seamonster.

Figure 2. Symo

Figure 3. Head of Executioner

Figure 4. Mary in Jesse Tree

Figure 5. Wisdom

Figure 6. Drawing after the Head of Lion

Figure 7. Longinus

Figure 8. Drawing after One of Absalom's mourners.

Figure 9. Key Pattern

Figure 10.

Figure 11. Sinopia drawing

RUSSELL LOWE

Russell Lowe is a Lecturer at the School
of Design, Victoria University of
Wellington where he teaches Drawing
and Interior Architecture theory and
design. Both his teaching and
research explores and develops
drawing as a theoretical/
conceptual/research
construct. Of particular
interest is the
development of drawing
as a research vehicle
at post-graduate
and especially
doctoral level.

**Electroliquid Aggregation and the
Imaginative Disruption of Convention**

'Why still speak of the real and the virtual, the material and immaterial? Here these categories are not in opposition, or in some metaphysical disagreement, but more in an electroliquid aggregation, enforcing each other, as in a two part adhesive.'[1]

This paper proposes that the advent of new technologies such as 3D printing have brought into focus the difficulty of defining drawing by connecting it to the application of specific skills and techniques. To deal with issues highlighted by typically divisive notions such as the virtual and the real, the computer drawing and the sketch, the paper will advance the proposition that drawing can be more cohesively understood as that which makes critical connection to the section as a convention.

If, as Deanna Petherbridge suggests, computer aided drawing is 'a fact of life and no longer needs special pleading', then it seems we might comfortably extend this luxury to the digital print. But Petherbridge resists this spreading of the definition of drawing by invoking a split along skills/techniques based lines:

In the teaching of design, the neglect of drawing [and perhaps one should use the German term Handzeichnung, hand drawing or sketch, to indicate which notions of drawing I refer to here] has both been occasioned by and complemented by the development of computer drawing. Within the fine art spectrum there has been no compensatory replacement for the devaluation of drawing. Instead there is a multiplicity of fragmented strategies by which different artists react to, embrace or ignore any of the technological procedures or traditional art techniques within the muddled pluralism that constitutes hyper-individualistic fine art practice...drawing...has been sidelined to computing competence.[2]

Strangely, by splitting notions of drawing (the sketch and computer), Petherbridge is complicit in the multiplication and fragmentation of strategies that ultimately and ironically lead to the privileging of certain skills/techniques over others. She sees the result of this as the sidelining of a once primary version, the sketch.

If rather than resisting the spreading of the definition of drawing we were to attempt to extend our understanding of its acceleration through and beyond the point where the notion of drawing might encompass new technologies, such as 3D printing, we may begin to develop a definition that operates on an inclusive but clearly delineated conceptual level.

The climb from a 2D digital print to a 3D print is an undemanding one. In one particular system (LOM, Laminated Object Manufacturing) sheets of paper are laser cut and laminated, the thickness of the paper providing displacement in the z dimension.[3]

In an only slightly more sophisticated technique developed by MIT:

Three Dimensional Printing functions [in the same way] by building parts in

layers. From a computer (CAD) model of the desired part, a slicing algorithm draws detailed information for every layer. Each layer begins with a thin distribution of powder spread over the surface of a powder bed. Using a technology similar to ink-jet printing, a binder material selectively joins particles where the object is to be formed. A piston that supports the powder bed and the part-in-progress lowers so that the next powder layer can be spread and selectively joined. This layer-by-layer process repeats until the part is completed. Following a heat treatment, unbound powder is removed, leaving the fabricated part. It can create parts of any geometry, and out of any material, including ceramics, metals, polymers and composites.4

The US Army (www.army.mil)...plans to install 3D printers in trucks so drivers can create on-the-spot replacement parts. A German company, Buss Modeling Technology (www.bmtec.com), has based its 3D Colourprinter on a standard Hewlett-Packard inkjet printer chassis. "You look at this 3D printer, and there's not a whole lot more to it than an inkjet.5

In 3D printing the fact the third dimension manifests itself physically seems to place this kind of print firmly in the realm of the maquette [preliminary model from clay, plaster, etc].

To understand the 3D print as a drawing requires a close reading of its surface. The sectioning and layering essential in the assembly of the third dimension maintains and relentlessly reintroduces the destabilising step of the digital. This insistence on the digital in turn reveals fragments of the objects section that can be seen as a halo around each layer. In this way the shifts, in and then up, that ensure the 3D prints third dimension simultaneously declare this print as slice, section and drawing. It is, as Spuybroek would have it, an *'electroliquid aggregation'* where the drawing and the third dimension enforce *'each other as in a two part adhesive'*.

Think – across the corners of a step pyramid. (Figure 1. [Slide 3 from the conference powerpoint presentation]).

To further extend our comprehension of drawing, might the special case of the 3D print as a sectional drawing suggest a more general proposition that to understand something in one, two, three, or more dimensions as a drawing relies on there being evidence of some critical connection to the notion of the section as a convention?

With this question the paper takes a more investigative and probing approach to maintaining the thesis. The investigation relies on Matta-Clarks *'imaginative disruption of convention'6*, a concept that promotes a useful degree of distraction or suspension of disbelief, and will present the outcomes from three drawing experiments as a vehicle.

The first experiment expands on an examination of Matta-Clark's *'Splitting'* project [1974] where the aconventional 'dematerialisation' of space and light parallels the obvious physical dematerialization to

make a drawing that operates in four dimensions. This experiment works with the convention of Industrial Design.

The 'parting line', a term most commonly heard in the field of industrial design, refers to the line left in a cast part that is created where the two or more sides of the mould come together. (Figure 2. [Slide 4 from conference powerpoint the presentation]). If one were to imagine a sphere cast from a rigid material, the parting line would circumscribe its diameter; this is to point out that if the line were to slip either side of the widest point, the sphere would be captured in the mould. The line of the cut or section through the mould complexifies in an exponential relationship to the number of undercuts in a part.

In this drawing, (Figures 3-4. [Slide 5-6 from the conference powerpoint presentation]), by Vikki Leibiwitz, the part that is cut was an industrial water meter. The path of the cut carefully maintains a distance on the release side of the mould. Then wax, in its warmed and fluid state, was poured into the meter's opening to flow through the counting apparatus and out; although not all that went in made it out. With a carefully timed cooling, the meter filled and the wax traced its inside limits.

Subtracting the mould reveals a simple peripheral section hatched by the band saw blade. The sections planar reliability has been lifted towards its centre and slowly forced into the mould by the rising fluid. The mould becomes a single surface tool used to create a complex three dimensional section; not unlike the industrial practice of 'Superforming'.

Superforming is a process used by car makers Rolls Royce/Bentley, Aston Martin and Morgan.7

It 'is a hot forming process in which a sheet of aluminium is heated to 450 to 500 degrees centigrade and then forced [by air pressure] onto or into a single surface tool to create a complex three dimensional shape from a single sheet.'

A lens is an 'optical element made of glass or plastic and capable of bending light. In photography, a lens may be constructed of single or multiple elements....there are two types of simple lens: converging and diverging. Both are used in compound lenses, but the overall effect is to cause convergence in light rays.'8

The camera lens also contains an apparatus called the aperture. The aperture, along with the shutter which is found in the body of the camera, controls the amount of light passing onto the film. This control occurs via an adjustment to the aperture's diameter.

With this drawing, (Figures 5-6. [Slide 7-8 from the conference powerpoint presentation]), Stuart Hay introduces a second aperture with a cut along the barrel of the lens. His goal was to cut a section along the cone of vision and record the perspective in a state of becoming. The process involved introducing light into the lens so that the emission from the cut, those rays that were stripped from

converging, would strike and expose photographic paper. The exposure in terms of both time and intensity is indicated by the saturation of the grey tone.

In 'The Cutting Surface: On Perspective as a section,Its relationship to Writing, and Its Role in Understanding Space'.9 Gordana Korolija Fontana Giusti talks about the notion of a writer's relationship to the page and promotes this affiliation as making a significant contribution to Alberti's development of linear perspective. In short, Giusti maintains that it was the page that inspired in Alberti the notion of the cross section through the cone of vision, the picture plane, and the subsequent development of perspective; rather than the idea of the window frame that surrounds but does not interfere with the scene.

A survey of Hay's environment shows text becoming hypertext, the page becoming the screen and the demand for the section coming into and through a cone of information. With this drawing, layers of hypertextual script, both word and image, are penetrated resulting in a hypersectional perspective existing between the digital and the analogue. Connecting the digital and the analogue to the in-between in this way might suggest an approach to understanding light as simultaneously wave and particle.

The second experiment, (Figure's 7-9 [Slides 9-11 from the conference powerpoint presentation]), revisits the notion of the Post Modern in Architecture where cutting and pasting, as in the collage/montage, takes on new significance with the advent of three dimensional printing. This experiment works with the convention of Interior Architecture.

The montage is a sub-version of the more inclusive notion of collage. Where the collage can be most broadly understood as 'any collection of unrelated things', the montage restricts those things to 'pictures or photographs'. The montage's specific concern for the representation of things extends to the 'method of film editing by juxtaposition or partial superimposition of several shots to form a single image'.15

This drawing experiment called 'Edinburgh' is a place to listen to music and play chess over the internet for a client in New Zealand. The name of this project and its location hints at the cut and displacement felt by the client during and as a result of his emigration from Scotland.

A similar strategy was employed in the drawing and design of the architecture.

Two presidents, Rossi's Memorial to the Resistance and Hadrian's Pantheon in Rome, were drawn, sectioned and interleaved in much the same way as one would mix a deck of cards. In the 3D print this juxtaposition transforms to a partial superimposition through the doubled nature of the stair and its bold signification of the digital.

The third experiment presents a three minute digital animation, (Figure 10. [Slide 12 from the conference powerpoint presentation]),

paralleling Sol LeWitts 'Incomplete Open Cubes'[11] with a supplementary set that reveals the gravitational dependence of his earlier complete, now incomplete, group. The result shows, in what seems like a direct contradiction to his established position, that LeWitt places outcome before concept. It is proposed that by installing versions in the landscape he fractures the horizon and forces the reading of these sculptural works as axonometric drawings. This experiment works with the convention of Landscape Architecture.

In 1967 LeWitt said:

'In conceptual art the idea or concept is the most important aspect of the work . . . all planning and decisions are made beforehand and the execution is a perfunctory affair. The idea becomes the machine that makes the art.'[12]

And,

'The artist cannot imagine his art, and cannot perceive it until it is complete.'[13]

In 1972 LeWitt published an artist's book called Incomplete Open Cubes. The book contained representations of the set defined by the skeletal structure of the cube. The open cube consists of 12 equal linear elements connected by eight corners. Each of the incomplete cubes contains from three to 11 elements.

The representations follow a straightforward formula. There is an index matrix at the beginning where all 122 versions are present with single line thicknesses as isometric drawings. Then each chapter or subset is introduced with a title and a partial matrix on the facing page. The chapters then count through two types of each version in an ascending order.

This splitting and stuttering as the idea is represented draws attention to its execution. There seems to be a difficult mirroring occurring through the spine of the book as both types negotiate ascension as conceptual/theoretical/virtual as opposed to physical objects. The drawing on the left page sits with its bloated whiteness pressing tellingly against an invisible platform. Both types share this masked acceptance of gravity and would, if physically realized, sit comfortably on a horizontal plane without tipping. This stability is reinforced on a structural level also. No elements of the open skeletal structure are fully released by the collective; none of the elements float freely, more, it seems, for the fear of crashing to the floor than floating off.

The axonometric is a projection defined by its immediate link to the plan, the reiteration and connection of its horizontal sections reach outward to bisect and spread the horizon.

The unframed and emaciated line drawing on the right-hand page seems to agree with the definition of the axonometric. In it, right angles in the horizontal plane remain so in the projection, parallel lines remain parallel, and lengths remain true. The drawing trapped in the heavy black void on the left-hand page also seems to satisfy the

conventions of its type, the perspective.

Both of these subscriptions to type require the assumption that the elements constructing the skeletal structure are as orthogonal as its parent body. A closer reading shows a difference in thickness between the left and right partners and suggests these two representations may be representing two entirely different sets. For a while the axonometric on the right page signifies that the representation on the left is one also until the perspective on the left equally as likely asserts that the drawing on the right page is a perspective too.

LeWitt engaged Dr. Erna M. J. Herrey, a physicist, to ensure the total of 122 versions was the absolute maximum number possible for this series. The extra 65 in the 2002 series present those versions with elements shaken loose by the vibration of a horizon that is repeatedly bisected only to then collapse into the space of the cut.

In this virtual space LeWitt's gravitational pull is replaced by the tremor of opening and converging lines between the axonometric and perspective systems.

The significance of this paper is that it promotes a paradigmatic shift in the understanding of drawing from a connection to skills and technique to a conceptual definition that makes critical connection to the section as a convention. This definition addresses the current splitting of the discipline and provides a framework for understanding things in two, three and more dimensions as drawings.

1. L. Spuybroek, 'Motor Geometry', Architectural Design, vol. 68, no. 5/6, 1998, p. 5.

2. D. Petherbridge, 'Subverting the Silicon: A Critique of Drawing in the Computer Age', UME 14, Queensland, Australia, 2002, pp. 2-5.

3. Geoff Harrold <http://www.cadinfo.net/editorial/z402.htm>

4. <http://www.mit.edu/ffitdp/whatis3dp.html>

5. <JEdwards@john-edwards.com>

6. G. Matta-Clark, Interview. International Cultureel Centrum, Antwerp, Belgium, 1977.

7. Refer to <http://www.superform.aluminium.com/technical/Forming/forming-cavity.html>

8. John Hedgecoe, The Photographer's Handbook. London: Ebury Press, 1995.

9. G. Giusti, 'The Cutting Surface: On Perspective as a Section, Its Relationship to Writing, and Its Role in Understanding Space', AA Files 40, Winter 1999.

10. Collins Shorter English Dictionary. London: Harper Collins, 1993.

11. S. LeWitt, *Incomplete Open Cubes*. Artists' book, 1972.

12. S. LeWitt, 'Paragraphs on Conceptual Art', in *Antform*, Summer 1967.

13. S. LeWitt, *Sentences on Conceptual Art*. 1967.

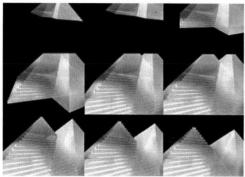

Figure 1. [Slide 3 from the conference powerpoint presentation].

Figure 2. [Slide 4 from the conference powerpoint presentation].

Figure 3. [Slide 5 from the conference powerpoint presentation].

Figure 4. [Slide 6 from the conference powerpoint presentation].

Figure 5. [Slide 7 from the conference powerpoint presentation].

Figure 6. [Slide 8 from the conference powerpoint presentation].

Figure 7. [Slide 9 from the conference powerpoint presentation]. Figure 8. [Slide 10 from the conference powerpoint presentation].

Figure 9. [Slide 11 from the conference powerpoint presentation]. Figure 10. [Slide 12 from the conference powerpoint presentation].

What Shall I Draw?
Just a Few Words

PHIL SAWDON

The thoughts presented here are a summary and distillation of a futile, despondent, illusionary, circular and often ironic project/journey of diary/journal 'drawings' by Phil Sawdon that are a response and reply to the question 'What shall I draw?' And to the statement, 'I don't know how to draw.'

It is written from the perspective (predictable pun intended) of a person who makes pictures, sometimes using drawing, so they might therefore be called drawings. I lecture and teach in both two and three dimensions, which is a trick I learnt in the 1970s watching a variety of 'psych' bands. I read about drawing. I practise my craft (is drawing a craft?) so that probably makes me a practitioner, who is becoming perfected by practise, but perhaps only in theory as opposed to fact. Drawing as practical theorising! Is theory only useful when its proof can be located in the drawings themselves?

The project and drawings are titled *The Artificial Sketchbook*, *'Le singe est sur la branche'*.[1] The drawings are a consequence and exploration of the 'process' of drawing, a process that Deanna Petherbridge describes in 1992 as a *'serial process of finding, refining, reformulating, questioning and constructing'*.[2]

The research, i.e. the careful, diligent search, and studious inquiry aimed at the discovery and interpretation of facts about a particular subject is so rock'n'roll. It's very fucking fast, very fucking furious and very fucking metal.

Perhaps not, more wishful thinking really, but some gratuitous, robust language and 'psychedelic' word trails are a feature of both the construction and the content of this paper and by association my drawing 'process'.

A key concept in the Art and Design community and especially the education community is that drawing is a form of language, a 'visual language'. The phrase visual language usually refers to the idea that communication occurs through visual symbols, as opposed to verbal symbols, or words. The phrase implies syntax, grammar, vocabularies, and a system for the expression of thoughts. *The Artificial Sketchbook*, that is the drawings themselves, explores the questions as to whether drawing is a visual language and whether it can be demonstrated that the process of drawing can be fully described. How does it do that then? Is it by the fact of its existence? The revision of accepted theories or laws in the light of new facts (in other words, research) in this instance is probably best answered by another question. Are the drawings and this project an attempt to describe a non-verbal process? If drawing is a visual language then is a series of drawings that set out to explore the process of drawing simply a form of tautology, or a case of the 'emperor's new clothes?' George Whale asks:

> What do we mean when we talk about visual language? Are we saying that pictures are in some way similar to speech or text? Or is the term simply a figure of speech, or worse, a piece of meaningless jargon?

In the same short article Whale goes on to ask several key questions:

'When is it legitimate to speak of a drawing as an expression of visual language and what are the similarities between visual language and natural language? Can visual artists be said to employ vocabularies and grammars, and to what extent is it necessary to know an artist's language in order to derive meaning from the work?'3

I feel the psychedelic and circular strains of academic viability and credibility beginning to tighten. Is The Artificial Sketchbook at the stage of development at which further development can occur independently of the author? Just to tighten the magic muscle a little further; 'a visual language is a pictorial representation of conceptual entities and operations and is essentially a tool through which users compose iconic, or visual, sentences',4 according to Professor S.K.Chang in his Introduction to the Visual Languages and Visual Programming course at the University of Pittsburgh (USA). My panic subsided once I realised that I was in cyberspace.

The Artificial Sketchbook acknowledges that 'drawing is seen as the quintessential expression of creative activity'5, and shares the 'commitment to drawing as a means of developing cognition, refining perception, enabling articulate and expressive visual communication'.6 However, acknowledgement is not necessarily agreement. Mark Harris writing for 'Tracey' asks why is drawing such a sanctified medium.

There is this aura of inviolability about its practice that puts it up there with sex as a kind of fundamental right and (rite) for young people from which good things like knowledge, maturity, and confidence will ensue. But who says this is true? Who's to say that ignorance, puerility, insecurity, and (institutionalised) abuse aren't often the result instead (as with sex)?

Is it because drawing arises like a visual ur-language from early childhood and has the status of a 'pure' communication?7.

Here are some more things you need to know about The Artificial Sketchbook before we carry on.

- Drawing is a picture or plan made by means of lines and marks on a surface, especially one made with a pencil or pen. A record of a tool moving across a surface. A verb and a noun.

- 'Artificial' is defined as produced by man, made in imitation, lacking in spontaneity, insincere and assumed.

- A 'sketchbook' is a book of plain paper containing sketches, rapid drawings and brief outlines of theories and works. It is defined by the Harvard University Art Museums in their Guide to Drawing Terms and Techniques as 'a book that contains drawing paper for sketches. It differs from an album in that the drawings are not adhered into the book but drawn on the actual sheets.'.8 The 'pages' of this

sketchbook are a series of free hanging works.

- The pages are one side of the leaves of a book where such a leaf is considered a unit. The pages of *The Artificial Sketchbook* are presented as a series, regularly issued and consecutively numbered 1 to 11. *They serve as a serial process of finding, refining, reformulating, questioning andconstructing,'9* a succession of related drawings arranged in a particular order. Here there is an inherent irony as the increasingly cyclical nature of the 'process' is contradicted by the linear and descriptive nature of *The Artificial Sketchbook* format.

Artificial Sketchbook: Page 1

The content and format of the project/ journey to try and answer the question of 'what shall I draw?' and its partner 'I don't know how to draw' is established on page 1 where items are listed as a checklist or inventory, in other words a detailed list. It is argued therefore that the first phase (page 1) in the 'serial process' of drawing might be to identify and manifest an inventory of issues and items requiring actions and decisions. Richard Wollheim in his essay 'Criticism as retrieval', a supplement to his book *Art and Its Objects*, argues that 'criticism' is 'retrieval':

 Retrieval, like archaeology (and archaeology provides many of the metaphors in which retrieval is best thought about), is simultaneously an investigation into past reality and an exploitation of present resources.

'*The task of criticism is the reconstruction of the creative process, where the creative process must in turn be thought of as something not stopping short of, but terminating on, the work of art itself. It is a deficiency of at least the English language that there is no single word, applicable over all the arts, for the process of coming to understand a particular work of art. To make good this deficiency I shall appropriate the word 'criticism', but in doing so I know that, though this concurs with the way the word is normally used in connection with, say, literature, it violates usage in, at any rate, the domain of the visual arts, where 'criticism' is the name of a purely evaluative activity.*'10

In other words, understanding the work comes through the retrieval of the creative process.

So it's back to the trowel and archaeology then.

The inventory referred to earlier is both 'written' and drawn in pen and ink on paper. This deliberately raises the question of whether handwriting is drawing. I will try and talk about autograph and, by association, style later in the paper. The items are *deleted* and identified as appropriate. They are the visual triggers for the content of the subsequent pages. This also includes the title, *The Artificial Sketchbook*. The inventory includes the following handwritten 'text' items:

'Actual Size-Life', 'The process of drawing', 'A serial process with a pen and a bottle of ink', 'Compressed fibre awaiting the serial process', 'A pen with a bottle of ink with a pen', 'Identify the surface', 'I like to draw to find cognition', 'Interesting little bits of writing'.

There are drawn elements such as a 'pen' and a 'bottle of ink', a pastel figure blowing a trumpet, another pastel figure 'dancing', a series of frames and a life-size outline of the artist/author's head. How do you make pastels?

'Blending dry powdered pigments with a non-greasy liquid binding medium such as gum arabic makes pastels. The resultant paste is usually rolled into a stick and then dried. A wide spectrum of pastel colours is thus possible, and by the eighteenth century, artists actively sought to imitate the fluid handling of oil painting through a colouristic and painterly style of draftsmanship. Although no actual examples are known today, sixteenth-century sources suggest that the earliest use of pastels was by Leonardo da Vinci at the end of the fifteenth century.'[11]

Fucking hell, it must be more interesting than this. To your trowels!

There is always an applied gloss surface somewhere within every 'page' as a literal and metaphorical reflection, and as a cosmetic sheen, superficial and attractive. Pages 2 to 11 inclusive develop aspects from the inventory list in a visual form. If one accepts that to illustrate is to clarify and explain by the use of examples, analogy etc., then it can also be argued that *The Artificial Sketchbook* is a series of 'illustrations' that explain the text through pictures.

The next section of this paper will attempt to summarise the stages and decisions of the serial process in order to answer the question, 'What shall I draw?' whilst acknowledging that I don't know how to draw.

Artificial Sketchbook: Pages 2 to 10

The 'pages' develop an aspect of the process and inventory in visual form so, for example, page 2 silhouettes and 'traces' the author/artist contemplating and drawing the incomplete phrase 'Pen and' where a 'Pen' is the implement for drawing using ink, consisting of a metal nib attached to a holder. Graphic crosses mark the graves of numerous failed starting points.

'The metal pen was not widely used until the second quarter of the nineteenth century when advanced techniques for stamping, bending and grinding became available .'[12]

'Pen and' is also contained and repeated as 'drawn handwriting' within the drawn author–artist silhouette and repeated in pastel across the banner frame. A dog sits.

Page 2 is a penned composition. The 'page' starts the drawing process by selecting the materials.

Page 3 completes the phrase 'Pen and Ink'.

Ink is a fluid for drawing.

Apple Green, Black Indian *Blue, Brick Red, Brilliant Green, Burnt Sienna, Canary Yellow, Carmine, Cobalt, Crimson, Deep Red, Emerald Gold, *Nut Brown, Orange, Peat Brown, Purple, Scarlet, Silver, *Sunshine Yellow, Ultramarine, Vermilion, Violet, Viridian, White Liquid Indian ink (Non-Waterproof).

*Available in 14ml & 30ml bottles.
Black only also available in 30ml bottles with dropper cap and 250ml or 500ml bottles.

How might we identify 'traditional' drawing inks in The Artificial Sketchbook and also in … old master drawings? Jan Burandt can help:

'Bistre, carbon, sepia and iron gall inks are all present in old master drawings. The manufacture and characteristics of these inks are discussed and visual clues, which aid in the identification of the media, are reviewed. Drawing inks of known composition were analysed with x-ray fluorescence spectroscopy and Fourier-transform infrared spectrometry. Case studies of examinations of ink drawings are presented to illustrate how these methods can be used together to identify inks of unknown composition.' [13]

Now I have the tools, pen and ink and paper, 'What shall I… Draw?'
Page 4 is the/my uncertainty and 'doubt'. The repetition of the phrase 'and what shall I' together with a graphic *deleting* of all the proposed 'subjects' within the drawing. To be able to understand the process of drawing, is one of the practitioner's tasks to come to terms with doubt and make it central to the act of drawing, with doubt working to prevent the securities of a lapse into style? Doubt as an unresolved point, uncertainty as a constant. Michael Phillipson (Painting, Language and Modernity) when talking about Philip Guston describes his practice as a *'restless movement, a ceaseless quest'*. [14] If we refer back to Petherbridge's earlier list of 'finding, refining reformulating and questioning', then an itchy arse might be an advantage. Phillipson's 'lapse into style' is obliquely referred to within Petherbridge's serial process of drawing and so to that extent it is a feature of The Artificial Sketchbook.

Petherbridge uses the phrase *'Questions of style and autograph'*. [15] What are the 'Questions of style and autograph?' I don't know. Yes I do. No I don't. Yes I do. No I …but within The Artificial Sketchbook I have included stylistic gestures (pages 5 to 9 inclusive.) Are they 'tricks of the trade', in which case we are moving back to the argument as to whether drawing is a 'visual language'. Gestural flourishes with a pen and some ink as part of a grammar or syntax within mark making. Is this style and if so is it separate from content? The conventions of expression, are they separate from intrinsic content and meaning? Nicos Hadjinicolao in Art History and Class Struggle, [16] which I will paraphrase, argues that style i.e. the way in which formal and thematic elements of a picture are combined on each specific occasion is a particular form of the ideology of a social

class. Therefore style is visual ideology. Visual ideology is the style of a social group. It is a specific combination of the formal and thematic elements of a picture through which people express the ways they relate their lives to the conditions of their existence, a combination that constitutes a particular form of the overall ideology of a social class. A shame then that he also states it is not an objective fact nor can it be identified with a fact such as a visual image and that it is not of the individual and it goes beyond the limits of a picture. Oh shit! Hang on though; I'm sure Michael Phillipson has something to add:

'There can be no final distinction between practice and theory. Each breaks up, fragments the other. Theory does not stop at the frame....'

Go for it Mike....

We need it and already have it in play in moving within the frame, but then our theorising will be confronted by the work itself, will be forced back on itself, will be split into oppositions, tensions, confusions, elisions, and so on.'[16]

Trowels!

'Autograph'. Is that a person's handwriting or signature? If so it is a preoccupation of pages 6 to 9 (inclusive) with the inclusion of transcripts of the Loughborough College of Art and Design Drawing Steering Group's minutes in my handwriting. One of the group's roles was to develop and promote what became the Drawing Across Boundaries conference and exhibitions at Loughborough in September 1998.

The symposium was set out to take a critical look at the nature and value of drawing activity across a broad range of contemporary art and design activity.

Pages 8, 9 and 10 contain a previous screenprint by the author/artist that together with the history/archaeology of the written 'Steering Group' notes are an ironic statement as well as a metaphor.

The 'signature' is a white ink handprint on page 7 with which I try and refer to the tradition of drawing history via the handprint of cave painting.

A pointed hat features on numerous pages, most particularly 5, 6 and 7 on the author/artist. The 'style' is both a dunce's cap, a conical paper hat once placed on the head of a dull child at school, and that of a witch or wizard, outstandingly clever in their specialised field. Incidentally, in the sixteenth century Dunses or Dunsmen was a term of ridicule applied to the followers of John Dunscotus, a scholastic theologian.

Trowel!

Is this what Richard meant by archaeology?
As the tasks that *The Artificial Sketchbook* attempts become increasingly more complex and cyclical, the author/artist attempts to summarise through collage and text the position that has been reached.

Page 10 is a drawing and collage. It includes the text: 'Pen and', 'Ink'

'and what shall I'. Collage is a technique that can be described as collecting together unrelated things.

There are drawn snails and their ink trails; these are a metaphorical reference to time both within the 'serial process of drawing' and the 'institutional' framework of some of *The Artificial Sketchbook*'s content. It is a snail trail of ink and words. An earlier version of page 10 is included within the Loughborough College of Art and Design (now Loughborough University School of Art and Design) Research Report for 1996. It is printed upside down alongside the following text:

Drawing is concerned with clarity, or with the act of clarifying where language cannot adequately perform that function[18].

Artificial Sketchbook: Page 11.☐

Page 11 is the final 'page' in *The Artificial Sketchbook*. The 'Drawing' as a noun after the verb and the answer to 'what shall I draw?' The consequence of and the answer to 'and what shall I? whilst always acknowledging that I don't know how to draw. It is both the product and part of the 'serial process'. Is it a set of visual symbols belonging to a system indicating aspects of meaning not otherwise conveyed in language? It is literally a sheet of drawn and traced silhouettes of an author/artist 'drawing' an author/artist 'drawing' an author/artist... Infinity.

What shall I draw? ☐

I shall draw the state or quality of being infinite in that there will be no limits or boundaries in time or space, extent or magnitude, but fortunately I don't have to worry because I still don't know how to draw.

Artificial Sketchbook: Post Script.

The use of quotation marks in a text is acknowledged as sometimes being an ironic reference and also a misnomer. 'Drawing' in this paper is no exception. Pictures are a representation, they are an illusion, the author/artist in the 'pages'/pictures has never been actually drawing in any of the 'pages'; it is an imitation, possibly insincere it is *Artificial* and *la souris est sur la table*.[19]

[1] Eddie Izzard, 'Dress to Kill'. Video, Ella Communications Ltd. 1998.

[2] Deanna Petherbridge, 'Comment: Drawing Conclusions'. *Crafts*, March/April 1992, pp. 18-19.

[3] George Whale, 'Is 'visual language' anything more than a figure of speech?' Tracey, < http://www.lboro.ac.uk/departments/ac/tracey/idal/whale.html> September 2001.

[4] Professor S.K.Chang, 'Introduction to Visual Languages and Visual Programming', <http://www.cs.pit.edu/ffichang/365/elements.html>

[5] Petherbridge, *Drawing Conclusions*, pp. 18-19.

6 Loughborough University School of Art and Design. *Department Handbook, First Year Undergraduate, 2001/2002*, p.5.

7 Mark Harris, 'Why is drawing such a sanctified medium?' Tracey, <http://www.lboro.ac.uk/departments/ac/tracey/edu/harris.html> December 2000.

8 E. Saywell, L. Straus and P. Straus, 'Guide to Drawing Terms and Techniques'. <http://baobab.harvard.edu/sargent/drawingglossary.html> Harvard University Art Museums.

9 Petherbridge, *Drawing Conclusions*, op. cit. pp. 18-19.

10 Richard Wollheim, 'Criticism as retrieval'. *Art and Its Objects*, Cambridge: Cambridge University Press, 2nd ed. 1980, pp.185-204.

11 Saywell, Straus, and Straus, op. cit.

12 ibid.

13 Jan Burandt, 'An Investigation Toward the Identification of Traditional Drawing Inks, <http://aic.stanford.edu/conspec/bpg/annual/v13/bp13-03.html> American Institute for Conservation, vol. 13, 1994.

14 Michael Phillipson, *Painting, Language and Modernity*. London: Routledge, 1985, chapter 7.

15 Petherbridge, op. cit. pp. 18-19.

16 Nicos Hadjinicolao, *Art History and Class Struggle*. London: 1978.

17 Phillipson, *Painting, Language and Modernity*, p.40.

18 Loughborough College of Art and Design, *Research Report*, 1996, pp. 18-19.

19 Izzard, op. cit. 1998.

STUART MEALING

Stuart Mealing is a Reader in Computers &
Drawing at Exeter School of Art, University of
Plymouth. As a practising artist, he exhibited
widely for many years before concentrating
on research into visual aspects of
computing. Since then he has had five
books and a range of papers published.
He has also been a Research Fellow in
Computer Science at Exeter University
and was a founding co-editor of Digital
Creativity.

 Towards a Life Machine

It has often been said that a person doesn't really understand something until he teaches it to someone else. Actually, a person doesn't really understand something until he can teach it to a computer, i.e. express it as an algorithm... The attempt to formalize things as algorithms leads to a much deeper understanding than if we simply try to understand things in the traditional way.[5]

If the Turing test were to be applied to drawing (i.e. given drawings of unknown provenance, distinguish between those created by human hand and those created by a machine), what would a machine need to 'know' in order to compete with any likelihood of success? This paper considers the question within the limited domain of objective drawing, personified here by life drawing, rather than that of imaginative drawing which has been the focus of most other work on computer drawing – notably Harold Cohen's program Aaron.[7] Both fields necessarily consider aspects of visual representation, human cognitive structure, artificial intelligence, etc. but objective drawing is concerned with representing a model whilst it is being observed by the artist and imaginative drawing with representing a model which exists in the artist's mind alone, albeit probably derived from memory of previously observed models.

Standing before a life model the viewer's retina is the recipient of light rays reflected from the scene in front – that part of the seeing process is similar to representation by a photograph in which tonal information is received, stored and presented two-dimensionally. The brain then processes the data received via the eye and renders the information understandable in terms of the real world, understandable in terms of previous experience. It builds meaningful cognitive primitives from an array of image intensities whose elements may be related to important physical regularities.[10] These primitives are both three-dimensional forms and carriers of association through past experience.

KIKI[9] is a computer drawing model, currently mainly paper-based. She provides the theoretical basis for a future computer-based system which would draw directly from a life model in the real world and thus provides a test-bed for algorithms of goal-directed mark-making, i.e. drawing. Elements can, have and will be realised but, in talking about algorithms for the criticism and creation of art works, Stiny and Gipps[13] very reasonably point out that:

'the specification of such algorithms is not a project for 7 man-years of work but for 7,000 man-years or for 7,000,000 man-years or for a civilisation. The amount that must be learned before such algorithms could be fully specified is enormous.'

Whilst KIKI could produce output by means of pen or brush on paper, the computer screen has been chosen as her natural medium. That does not preclude subsequent printing of the screen image but any such will be considered as a reproduction, with all the caveats that brings with it, rather than as an original work. Using the screen removes some of the material elements that could tilt the playing field

in a Turing test and also some of the potentially autographic qualities. The difference between screen-based marks and those made manifest on paper (or other physical material) is an interesting one discussed elsewhere.[8]

Inputs

KIKI has both two- and three-dimensional inputs. A picture file gives her a 2D tonal image of the external figure in the scene before her and an internal 3D model of a human figure is aligned with her view and proportioned to match the real world model. This internal surface model of the human figure has information associated with it in the form of an expert system and can be interrogated by the system so that, for example, 2D tonal areas can be associated with body parts and joints. These parts have data attached which describe the tensions and other local significances in the body which might influence the marks used to represent the region.

If you or I draw a human figure we not only have visual data from the model in front of us but bring to the act of drawing both the experience of having seen human figures before and our own intimate knowledge of inhabiting a human body, of knowing how joints work and how tensions feel. We will also have drawn before, seen drawings before and passed through the point where perception is replaced by inductive reasoning. KIKI's internal model will be initialised with, and will add, data that relates to these experiences – or at least to the manifestations of these experiences. She does not model herself on the evolving drawing of children, a popular area of research in sciences involved with cognition, but on mature, 'knowing' drawing. A child is more likely than an adult to represent in a drawing what it knows about the subject rather than (or in addition to) what it sees. KIKI is, however, visually driven and operates on a graphic schemata.

At this time two- and three-dimensional data are taken from a commercial figure modelling application to allow KIKI's workings to be developed, to allow drawing algorithms to be devised and tested. No real world figure is yet viewed. It is intended that collaboration with researchers in the field of robotic vision will later provide an active input system in which a camera provides 2D data from a real scene and systematic interpolation is used to align the 'seen' model with the internal representation. A likely method is for a part of the internal model, perhaps the head, to be aligned by trial and error with the tonal representation. Once a fit is found between the picture of a head and the model of a head (scaled as necessary) then the head position will be locked and subsequent parts of the body hierarchy aligned and scaled – neck, shoulders, torso, upper arms, lower arms, etc. in sequence. If a body part is hidden when looked at from the current viewpoint then a realistic positioning guess will suffice as that part will not figure in the subsequent drawing.

Scene recognition is a major area of study in the fields of robotics and

artificial intelligence and much has been written about the extraction of 3D information from camera-sourced data. In computer graphics there is also much current interest in the extraction from photographs of data for the creation of 3D models. Whilst these fields of enquiry might come to offer alternatives to KIKI's internal model they are targeting different goals. Understanding the scene in order to draw it is not the same as understanding it in order to negotiate it spatially or interact with it in some way (which are likely goals for robots). Whilst more intuitive methods of relating image to 3D form might thus become available the internal model is seen as a necessary means of associating other information with the figure.

Processing

A range of different data types need to be brought together and reconciled in order that KIKI can act on them. These include the 2D input from the scene, the internal 3D model and its associated information, rules for mark making (and later a mark library) and various feedback. The blackboard metaphor used in the field of artificial intelligence is a good, intuitive match for the requirements of the system to enable decisions to be made and is proposed for use here. A conventional blackboard architecture is a shared decision space for memory and interaction between a number of knowledge sources.

Some raw inputs will be processed before they reach the blackboard. For example, a number of standard image processing methods can usefully be applied to the scene data. Edge detection is a basic part of an artist's repertory, often providing the basis for key marks in a drawing, and is simulated by readily available image processing algorithms. If a line was created to represent an edge it could be converted to vector form and would then be open to modification through its control points. This could provide a ready starting point for controlled exaggeration or stylisation, driven perhaps by the information associated with the body part of the internal model to which the image data mapped.

Rules on formal and intuitive perspective could also underwrite decisions about stylistic distortion. Whilst knowledge of perspective is not necessary in order to make marks which stand for the 2D scene data, it could be called upon to reinforce the implementation of marks denoting space.

Goal-Directed Mark-Making

Cohen's Aaron creates a picture from imagination. Cohen says 'I don't tell it what to do. I tell it what it knows, and IT decides what to do.' In Aaron's case the program knows about general rules governing the shape of vegetation, people, jugglers and more. Also about issues such as how to pose the body and deal with occlusion in the image. It makes its own composition using the rules provided and does so using essentially one type of linear mark which is mainly concerned with defining the

edge of a form. The results are fascinating.

KIKI confines herself to making marks that stand for the figure before her; there is no imagination used in her choice of subject. The main focus of interest is in the decisions about where to place marks in order to explain characteristics such as form. Initially these marks are simply monochrome lines of uniform width and weight and they do not attempt to deal with surface tone. Later they can swell, taper, stutter and decay. But where to put them? How does an artist decide where to touch pencil to paper in response to the subject?

A primary distinction might be between lines that record horizons, i.e. that indicate where the edge or boundary of a form is (as seen from a single viewpoint), and those that cross forms. The latter might serve to explain a surface or contour and in order to be able to do this KIKI can refer to her internal model. Marks can also be symbolic references to weight, stress and tension in the figure. Since such forces come to be understood largely through experience of having a body, their significance will have to be made available to non-corporeal KIKI through the expert database linked to the internal model.

The concept of a profile-stroke (P-stroke), conceived in the context of cartography, might be usefully considered. Visalingam and Dowson[14] suggest that:

'Like a map, a sketch is a graphic precis of reality. The cartographer brings to field sketching his skills in cartographic generalisation which includes the processes of selection, simplification, classification, symbolisation, displacement and exaggeration.[12] *...the aim is to select from the landscape those critical and important lines which give it character...'*[6]

P-strokes are lines originating from core cells algorithmically identified because they indicate significant, scale-related convexities and concavities on the surface. Whilst it is impossible to deconstruct a Matisse drawing and determine the geographical significance of the lines denoting a face or a naked torso, there is a clear sense that the artist has, through instinct born of analytical experience, identified passages of particular significance as the focus for his marks. One cannot fail to recognise, of course, that the topology of a Matisse figure is being described in an emotional and refined aesthetic context.

KIKI will later contain a library of mark primitives and mark attributes which can be called upon and modified. Variables will include width, texture, weight, direction, continuity, etc. Whilst these will start by simulating mark types and conventions derived from human drawing, the possibility exists for the system to be allowed or encouraged to develop novel marks; novel, at least, in the context of machine drawing.

Sequence

KIKI must have a starting point for a drawing and must decide when it is finished. At a later stage composition (initially at least within a typically rectangular format) will need to be considered and, subject to the addition of a mobile robotic vision system, choice of viewing position. At that stage prior intention becomes a factor – what visual problem(s) is the drawing to address?

The decision to start at any particular point could be arbitrary but will be increasingly informed by an accumulation of feedback, as will the decision to move on from a mark made at one point in the drawing to another point which is seen (at that moment in time) as being appropriate. Drawings do not knit themselves from one side of the sheet to the other — the artist employs a strategy which derives from an overview of the developing drawing, and conceived in the context of a driving intention. This leads to marks being laid down at locations significant to the artist without, of themselves, necessarily describing the scene to any outside viewer.

Drawing is often not a purely additive process. Marks can be removed as well as added, although the act of erasure can be seen as adding another type of mark. In the real world erasure is rarely absolute: it smudges, leaves traces of the previous marks and it disrupts the surface. It serves to reveal something of the drawing's history and lends it probity. In a computer paint system, where each additional mark can have its own identity, erasure could be carried out by undoing the mark as if it had never existed. The philosophical consequence of removing a mark that has already interacted with others is a local example of the problems arising from time travel. The drawing would have to reinvent its future from the point at which a change was made to its past.

Man-in-the-Loop

A drawing is informed by real-time evaluation of the work as it progresses and future drawings by retrospective evaluation once it is completed. In fact, the moment of completion might be the climax of a series of proto-retrospective evaluations. Deciding when a drawing is finished is a defining task for an artificial system. The significance of evaluation is vital in the assessment of a process as being creative.[2] For monkeys to type Hamlet is only creative if they select and present the final play in preference to the non-Hamlet material they have produced.

The criteria by which a developing human drawing is internally assessed are complex and driven by many experiences that a virgin machine would not have. The tabula rasa will, however, rapidly gain experience from the feedback data and from the expert system, which will itself grow and be modified.

It will be necessary for KIKI to learn and in the first instance heuristic feedback will come from a man-in-the-loop, in this case the author. This feedback will be provided both dynamically as the drawing evolves and retrospectively once it is finished. Several elements of her output will be approved against an incremental scale using the criteria of her 'teacher' – success in identifying significant features, success in rendering individually identified features (i.e. knees), efficiency of the marks (i.e. avoiding unnecessary redundancy), composition, some sense of *gestalt*, useful novelty, and more. It will come to be seen what degree of external direction is required as the program self-modifies but an ultimate (though distant) aim would be for the external feedback to become redundant and for KIKI to assess her own work according to aesthetic criteria she has evolved. This development of aesthetic judgement is, however, postponed.

KIKI Rules

'A necessary condition of machinehood is that one can causally trace the object's behaviour output to its internal states.'[3]

KIKI will operate on the basis of relatively simple rules; simple, that is, by comparison with the hidden 'rules' governing human action which are developed over a lifetime through the complex programming of experience. Her rules will be rigorously domain specific whilst a human will necessarily bring knowledge from many other areas of existence to the life room. She will not have cultural, historical or narrative perspectives on the images she creates. It will be instructive to see how soon the shallow database on which she can call will be sufficient to produces images that could be mistaken for man-made.

KIKI will act on rules about drawing which effectively constitute an expert system and which carry weightings to qualify their application. These rules will describe where to make marks (judgemental) and how to make marks (mechanical) and will be derived from prior observation, research and human experience. External feedback will be able to directly modify the weightings retrospectively and to inform the system which can then make modifications dynamically. There will also be rules about aesthetics which will develop largely from feedback.

It is the case that the interaction of one or two simple rules can lead to behaviour which appears too complex to unravel. An elegant example is the flocking systems of Craig Reynolds[11] in which 'birds' are given just three basic rules based on collision avoidance, velocity matching and flock centering. This is sufficient for a 'flock' released into 3D computer space to act as if governed by a single intelligence greater than the individuals contained within them – to soar, split around obstacles and reform, and perform exactly like real-world birds. They appear to have corporate intelligence.

The judicious application of a little stochastics (randomness within defined parameters) adds spice to the action and guarantees some element of novelty – caveats about computers and randomness are not for discussion here. Systems intended to be creative often inject random factors into their process to improve the chance of surprise, by the observer, or novelty. To be considered creative, of course, requires that an act or artefact is not just novel but also useful within appropriate terms of reference.

Whilst surprise might only indicate an inability to anticipate the result of randomised interactions, it does provoke useful reassessment of what is going on. Hofstadter[4] and others argue that 'randomness is an intrinsic feature of thought, not something which has been artificially inseminated' and the notion of playful exploration as a part of the creative problem-solving process is common. It therefore seems wholly appropriate to build elements of controlled randomness into KIKI and to reinforce fruitful behaviour resulting from it.

The Creative Machine

It is difficult to consider the mechanised and/or computerised production of art work without the subject of creativity being brought up. Cohen says when talking about Aaron that '"creative" is a word I do my very best never to use if it can be avoided'[1] but Aaron's work continues to provoke that very discussion. I find that defining 'art' is rarely useful but that considering the definition of creativity can be, particularly in the context of artificial intelligence where it is often provocative and usually entertaining. Creativity and intelligence are symbiotic and there is an undeniable frisson about juxtaposing the words 'creative', 'intelligent' or 'art' with 'computer' or 'machine'. The notion of a creative or intelligent machine invites fresh perspectives on the human condition.

It has been clear for many years that enquiry into artificial intelligence – or at least philosophical enquiry into artificial intelligence – has involved the regular moving of goal posts. Perception of intelligence has often been rigidly linked to the ability of humans alone, so that something seen as evidence of intelligence is reclassified as not having required intelligence once it has been duplicated by a machine. Similarly creativity. But it is for the very reason that machine intelligence and creativity bring established understanding into question that they are valuable subjects for research and discussion. As with 'art', absolute definitions of 'intelligence' and 'creativity' are usually less interesting than the arguments surrounding them.

At a basic level KIKI tests our understanding of some of the processes at work in human drawing. At a meta-level she might be considered an artist herself. Her operational strategy leaves open the door to emergent behaviour – something happening that is not specifically programmed in. By her very nature she provokes questions both about the nature and the *raison d'être* of drawing as well as about the specifics

of mark-making, some of which she will hopefully answer.

Whilst this might tell us something about human drawing, it might also tell us something about how machines could develop. If we can, as has often been claimed, come to understand the world through drawing, then might drawing provide a fresh route for machines to gain useful intelligence about their world?

1 H. Cohen, 'Colouring without seeing: a problem in machine creativity', 1999.
 <www.kurtweilcyberart.com/aaron/hi_essays >

2 M. Elton, 'Artificial creativity: Enculturing computers', *Leonardo*, vol. 28 no. 3, 1995, pp. 207-213.

3 J. Haugeland, *Artificial intelligence: The Very Idea*. Cambridge, MA: MIT Press, 1985.

4 D. Hofstadter, *Godel, Escher and Bach: An Eternal Golden Braid*. Harmondsworth: Penguin, 1979.

5 D. Knuth, 'Computer Science and Mathematics', *American Scientist*, vol. 61 no. 6, 1973, p. 709.

6 A. Lobeck, *Block Diagrams and Other Graphic Methods Used in Geology and Geography*, London: John Wiley & Sons, 1924, p. 165.

7 P. McCorduck, *Aaron's Code*, W.H.Freeman and Co., 1991.

8 S. Mealing, 'Drawing in a Digital Age', *POINT*, no. 6, 1998, pp. 6-11.

9 S. Mealing, 'KIKI – A Computer Drawing System', *Proceedings of Eurographics 98*, 1998, pp. 121-6.

10 A. Pentland, 'Perceptual Organisation and the Representation of Natural Form', *Artificial Intelligence*, vol. 28, 1986, p. 293.

11 C. Reynolds, 'Flocks, Herds and Schools: A Distributed Behavioural Model', *Computer Graphics*, vol. 21, 1987, pp. 25-34.

12 A. Robinson, R. Sale, J. Morrison and Muehrcke. *Elements of Cartography*, London: John Wiley & Sons, 5th ed., 1984.

13 G. Stiny and J. Gips, *Algorithmic Aesthetics*, California: University of California Press, 1978, p. 5.

14 M. Visalingam M. and K. Dowson, *Algorthms for Sketching Surfaces*, Computers & Graphics, vol. 22 no. 2-3, 1998, pp. 269-280.

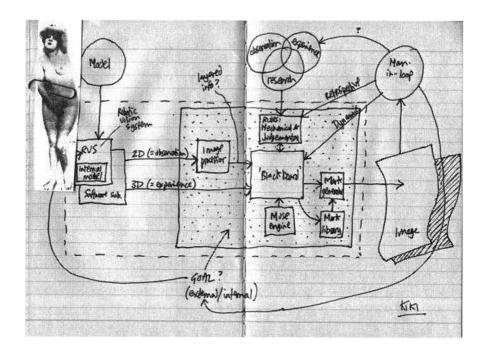

LEO DUFF

Leo Duff studied at Brighton and then the Royal
College of Art, moving from photography and
communication to illustration. Her work is
concerned with a sense of place, being
centred in the main on buildings and
their environment. Leo generally works
to commission, with exhibited work
developed from the locations visited
for these projects.

She has created and is director
of the MA, Drawing as
Process, at Kingston
University where drawing
research is focussed on
the use of drawing for
and by designers.

 In Discussion with Zandra Rhodes

Zandra Rhodes was born in Kent. She was influenced by her mother, who was a fitter at the couteur house Worth and who also taught at Medway College of Art, where Zandra became a student of textile design. During the summer prior to studying at the Royal College of Art, Zandra completed two exacting studies of a cabbage and a stinging nettle, which she still considers amongst her most important drawings. Within a year of graduating from the Royal College (1966), Sylvia Ayton and Zandra Rhodes opened a shop on London's Fulham Road to sell their designs. This was followed by her first solo collection in 1969. Her reputation as one of the most trail-blazing young British designers took off at this point and since then she has maintained a leading role as an innovative artist designer. Her fabrics and designs retain their invigorating freshness and are sought after all over the world. Zandra Rhodes, the person, has also become a modern legend and icon of the originality and spark of Contemporary British Design.

Zandra's energy and drive are a force much recognised and respected by those who have been lucky enough to witness her working ethos, not least the thousands of young artists and designers who have been able to work in her studios and education programme over the years. Currently Zandra lives and works in both California and London, where, in Bermondsey, she is creating the Fashion & Textile Museum. We met there to discuss her thoughts on drawing for inclusion in this book and to select drawings describing her working process for the exhibition 'Drawing – The Process'.

I began by asking Zandra about her main influences.

Sylvester Shaw, the drawing tutor at Medway, made a lasting impression and under his guidance she developed a real passion for drawing. She would spend days, regardless of the weather, be it night or day, snowing or raining, drawing outside. The subject was buildings and more buildings. On one occasion she spent three mornings in the doorway of Rochester cathedral, working with pen and ink on paper which, under Mr Shaw's tuition, had taken three days to stretch.

Zandra felt that if asked to do that again she simply couldn't – even though she would like to. However, she still goes out drawing and had several drawings around her desk which made the previous week.

This led to the subject of contemporary students' attitude to drawing.

Zandra commented that most students do not see any need to spend a long time on a drawing, favouring speed over a more considered and sustained period of observation.

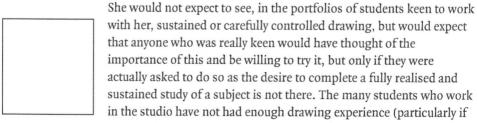
She would not expect to see, in the portfolios of students keen to work with her, sustained or carefully controlled drawing, but would expect that anyone who was really keen would have thought of the importance of this and be willing to try it, but only if they were actually asked to do so as the desire to complete a fully realised and sustained study of a subject is not there. The many students who work in the studio have not had enough drawing experience (particularly if

from the USA, where computers dominate) to develop good hand and eye coordination. They get a new experience during a work experience at Zandra Rhodes' studio where playing, experimenting and developing a drawing is their main occupation.

We looked at two drawings with watercolour, one of a stinging nettle and one of a cabbage which were drawn just before she started at the Royal College of Art. Each piece had taken over a week to complete and they hang in her dressing room amongst family photographs and momentos. Zandras affection for these pieces and empathy with the subject shows a real grounding of her working process in thoroughness.

The ideal time to draw now is on holiday. Zandra calls this sketching, although her sketch books contain many drawings which have clearly taken much longer than the hour and a half she suggests as being the least time she would spend on one piece. The difference between 'sketching' and 'drawing' is a subject that we discuss briefly, mainly because the term 'sketching' infuriates me. I can assure you that none of the work in Zandra's sketchbooks comes under the term 'sketch' as I or many others would use it, as there is a directness and clear focus with continued concentration of eye and hand on virtually every page. Zandra has given herself many rules in drawing, one of which is 'you must never tear a page out', and as I looked through the boxes of sketchbooks spanning over thirty years, I bore witness to this having been an unbroken rule.

There are two types of sketchbooks. One type is Aquarelle Arches Watercolour blocks of 100% pure cotton, white paper (about A3) in size. They contain, amongst other things, early ideas leading to the first designs for the famed punk safety pin dresses. These are still used for realistic and precise drawings and watercolours of flowers when time is available (on holidays) to actually complete such studies. Zandra still loves to work in these conditions on beautiful stretched watercolour paper, but says that in general 'good' paper makes her feel uptight. The favoured paper and sketchbook is now, and has been for some time, Japanese typing books. These have a stiff card back, are also approximately A3 and contain well over fifty semi-transparent, lightweight, natural coloured pages. Although they have a front cover, the pages are held together with clips, a sheet of white paper being inserted under the page while it is being used. The paper, although it looks fragile and lightweight, is clearly very robust as Zandra has filled many of the sheets with vigorous pen and ink drawings as well as using felt tip pens with very fast and firm movements, frequently covering the entire sheet. Themes appear, recur, change and float across the pages. Drawings are still carried out by night as well as by day, and although the materials used are ungiving in terms of soft or subtle shadow, the atmosphere and weather is made evident by colour. One reason for never tearing a page out is to witness progression, to see if things link up, if the eye and mind and hand can work together to clarify and identify the trueness of the subject. The pages, which are shiny and smooth on one side, are matt and softly surfaced on the other. They are quite transparent and can only be

worked on clearly if one side is used. This means that images can be glimpsed through the sheets, a delicious layering of shapes and colours which are reflected in Zandra's designs when printed on chiffon and fabrics which fall in folds, intensifying colours, patterns, irridesent dyes and blocked prints where they overlap.

Does Zandra draw every day?

No, but she wishes she did, and wishes that she had time to spend days on only one drawing now and again. She used to draw every day, in fact said it was all she did while a student – when she would even take her sketchbook to bed. This was, and still is drawing ideas as well as objects. Drawing ideas and developing ideas, annotated with reminders of passing thoughts for possible directions to take next, or references to be looked up, or cross references to previous ideas to be re-explored. This is the process through which Zandra develops her designs, be they for fabrics or collections, clothes or interiors. In San Diego she does a drawing class at 6.30 a.m. with anyone who will do it with her. This serves to make her draw and continues the discipline of drawing and the self-discipline so desperately sought by all working creatively in a studio-based situation.

 However, on holiday Zandra does draw every day, the ideal holiday being one spent drawing. Another rule appears, 'you must never use a camera', it will not and cannot supply the details that can be achieved in a drawing. A camera is no use at all when it comes to drawing. You can use it for some back-up perhaps, but the information seen through the lens will never enter your mind or your eye the same way as when drawn. When you look through old sketch books you can remember everything that was around you – smells, sounds, the time of day, the weather, the feel of the air, much more of the scene than you put on the page. The sequence of events can also be recalled with clarity and this is helped by the other rule of not tearing out any pages. Maybe the camera does not work because it doesn't make the effort, because it's so two-dimensional.

The continuity within your sketchbooks is reflected in your completed designs. Is this intentional research?

Zandra never sets out to draw anything with the conception that it will become a design. Otherwise the drawing would become separated from the flow of looking, creating, developing which is needed to make thorough artworks which will stand the test of time, 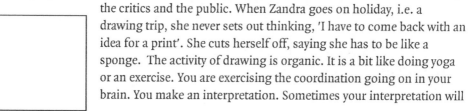 the critics and the public. When Zandra goes on holiday, i.e. a drawing trip, she never sets out thinking, 'I have to come back with an idea for a print'. She cuts herself off, saying she has to be like a sponge. The activity of drawing is organic. It is a bit like doing yoga or an exercise. You are exercising the coordination going on in your brain. You make an interpretation. Sometimes your interpretation will

be very accurate, for example making notes on what a plant looks like – another time it might just be the atmosphere of what it looked like. We looked at some drawings made recently in Egypt. Some of them were at the *Sol et Lumier*. They were made in the dark and were not accurate as they were reflecting that particular experience and were made with bold marks using a thick pen. Others were making notes on what the figures were like on tombs and these were finer and much more accurate. Many drawings in the sketchbooks are very accurate – doing something accurately is part of the experience, of the drawing and through the drawing, of the subject. When she has a drawing class 'all draw equally' bearing in mind these rules: the sketchbook with no pages torn out, you must never destroy what you are doing, if you don't like it too bad – you must still continue with the drawing.

How do you see the relationship between two and three dimensions?

We discussed how very informed by three dimensions Zandra 's clothes designs are, for example with cut-out shaping, layering and fluctuations in the weights of fabrics within one garment. There is also a strong three dimensionality to many of the fabric prints. Looking at art in general, it is often the three dimensional artist's work which speaks to Zandra most, the drawings of sculptors in particular. When drawing out clothes designs on paper, holes are cut for the arms and the paper then tried on as a garment, so Zandra can look at it on herself in the mirror. Has a life size drawing been created ? 'I draw to scale, in my sketchbook and while the idea is forming they are little, but then when I am making the design I draw it the size I want it to be.' For example, a fabric repeat is about 45" and the fabric about 45" wide, so it is out by eye and then when it's ready to take on to the next stage, when it is becoming more controlled, it is tried on. I think I want to see it so I try it on. The relationship between two and three dimensions for someone designing the print, selecting the textile and also designing the clothes must be very unique.

Zandra Rhodes has frequently been described as first an artist then a clothes designer. This seems to come from first loving the fabric, and then cutting and forming the three-dimensional shape in response to the fabric in its entirety. Not being taught to make dresses means the fabric is treated in a different way, through the pattern and texture first and foremost – feathers, cacti, shells or skyscrapers are cut around, the drawing influences and informs the shape – 'the print always has something to say'. The cut is a response to the print, the shapes then arrived at are also a response to the print.

So when you make a print, do you think in advance and plan the cut?

This happens to a certain extent as of course the screens have to be paid for. But that never guarantees it will work the way you thought it

would. With pattern work you are involved as if working with mixed media. On one hand, you are working with a two-dimensional surface, but is has a wonderful mixed sensation about it: line, tone, volume, both sides of the fabric, overprinting, differing surfaces, layering, giving it a three dimensional quality that can be handled and formed.

Do you consider yourself as someone who thinks in an interdisciplinary way?

Most of Zandra's friends are artists, who work in many different methods and with different materials, some two and some three dimensionally and without the aggravation of seperation of 'art' from 'design' and she gets her inspiration and outer influences from them. If going, say to an exhibition, or is offered a trip to which a husband and wife would usually be given tickets, Zandra goes with a long standing friend, usually Andrew Logan, and they end up doing a sketching trip together – to China, to India or Morocco. This is not so much a specific influence as an opportunity to sound off ideas, to come back with a fresh way of looking.

When Andrew and Zandra travelled to China they knew each would return with new ideas. They both like to sketch, shop and sightsee. Andrew will say, 'Oh get that. You'll be able to use that' or 'Why don't you try this'. There is a strong and mutual enthusiasm. Enthusiam is electric and it takes you a long way. It is inspiration; it also creates an eclectic viewpoint and subsequently wider possibilities.

Zandra transports and manipulates a really solid object such as a skyscraper through drawing and lets it float and sparkle.This is partly achieved by the use of fabric and the transient qualities of the layering and cutting she employs. It is also created by the use of colour. One large print, Banana Leaves, is based on the banana leaves which were outside the camper van she and Andrew were using. The originals were drawn in green, black and cream. But when developed into print pale pinks and beige were applied, transforming the feeling of weight and solidity into lightness. Many of the clothes in the collection of Zandra's work at the Fashion and Textile Museum look ready to move, they were never meant to be static. Zandra insists that instinct and constantly playing around is the way she achieves the end result. This is a vital part of her working process. 'You try something out, you put it on, you don't always know what is going to happen, if it is going to work.' You need to experiment all the time.

What would the dream drawing situation be?

Zandra hates crowds of people walking past while sketching, peering

over her shoulder and asking irrelevent questions or making inane comments. Years ago, while drawing in an allotment a man came up to her and said 'Oh, my friend can draw lovely parrots.' The constant thieving of materials by little kids India or Africa is wearing. So its absolute peace and quiet which would be perfect, concentration undisturbed and the chance for mind, eye and hand to work together for hours on end.

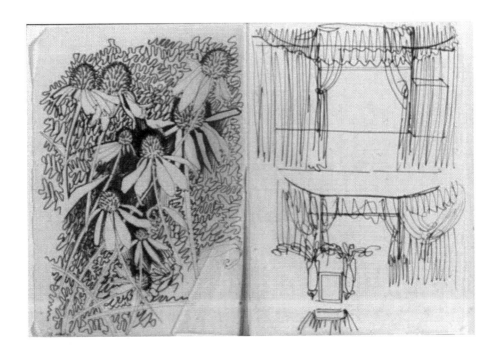

Courtesy of Zandra Rhodes and Kingston University Drawing Study Archive.

Alorythmic Drawings HANS DEHLINGER

We here distinguish two different universes of drawings, each one having its own unique properties: the universe of hand drawings and the universe of algorithmic drawings. In each one we find good and poor works, but they all will display characteristics, which definitely sort them into one or the other.

The universe of hand drawings contains all drawings made by artists since artists are around (which is roughly 30,000 years). This universe has many departments: that of the hastily produced sketches, that of carefully finished compositions, that of scientific illustrations, that of the drawings of the human figure, that of the landscapes, etc. The universe of the hand drawings is enormously rich. Its wealth is based on the power of the human imagination, the sharpness of the eye and the motoric capacities of the hand. Besides this universe there is a universe of algorithmic drawings. It is just as extensive and impressive, like that of the hand drawings. 'Algorithmic drawings' are drawings that are produced by strictly formulated rules.

The concept of algorithms is named after Abu Jaf'ar Mohammed ibn Musa al Khowarizm, a Persian mathematician who published a procedure to solve quadratic equations around the year 825. If we define a procedure as an instruction for acting, where at each step it is clear what the next step will be, we can understand an algorithm as a procedure which ends after a finite number of steps with a result. In computer programs, algorithms play an important role and each program is itself an algorithm.

Sometimes artists decide to subject themselves to self-imposed restrictions that run close to what is understood by a 'program' in information technology. Sentences like: 'draw a tree with short, violent strokes', 'use only vertical strokes of same length', 'go to and fro along a contour', etc., are examples for such 'programs'. One can imagine the possibilities over which the drawing hand can range as a continuum (see. Fig. 1, left side), which on the one hand of the axis marks a strictly rule-guided use of lines, which is gradually turning into a use of lines not following any rules at all and on the other axis a line, which is gradually moving towards 'painting'.

When we formulate rules for drawing by hand with increasing sharpness, we move towards algorithmic drawing, and at some point cross the border separating both. Then, we also find a continuum of possibilities (see Fig. 1, right side).

Interesting examples for the use of algorithms in the generating of drawings (and paintings) by artists have been published by the artists of the renaissance in their struggle to solve the problems of the perspective presentation. To construct the 'correct' perspective image of a lute, Dürer has illustrated a procedure in the woodcut of 'the draftsmen of the lute' and gives the following 'algorithm': the assistant strains a thread that runs through the picture plain (represented by a frame, behind which the master is sitting) to a point on the lute. The master mounts two threads to the frame so they touch the tense thread of the assistant. Then the assistant loosens his thread,

closes the door on the frame and the master transfers a point to the door, which is opened again by the assistant. Then further points are determined in the same manner. The table in Fig. 2 shows in the left column the steps of Dürer´s algorithm, and a significantly improved algorithm in the right column. In the Fig. 3, a 'woodcut' is shown that Dürer did not make, that he could have been able to make, however.

It seems unlikely that Dürer has actually used this procedure. He would have realised its clumsiness and probably would have changed it to do a faster job. He may also (as Hockney suggests) have known about other means to map 3D into 2D.

To generate drawings algorithmically we have to make some conceptual decisions. They are very likely based on individual preferences of the artist as well as on his intentions. Artists using algorithmic approaches (like Verostko, Mohr, Wilson, Zach, Struwe, Steller – to name a few) have created a very distinct and interesting body of work. In the case of my own algorithmic line drawings, I use a type of polygon, which I think of as my personal definition of a polygon. It makes the drawings distinctly, and in an identifiable way, my drawings. Other artists would probably use other definitions for lines and arrive at other very distinct, and in their way, unique results. The 'tree' in Fig. 4 shows an example of one of my drawings, which was generated in a one-shot-operation. It belongs to a set of drawings for which a sort of algorithmic minimalism is applied. The aim here is to generate drawings with an absolutely minimal set of commands.

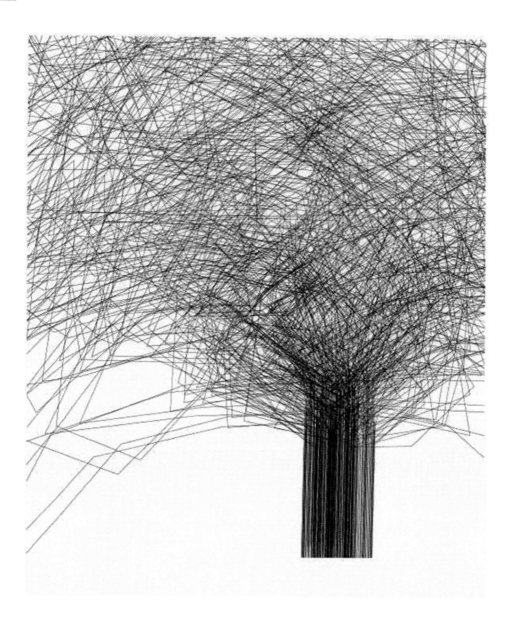

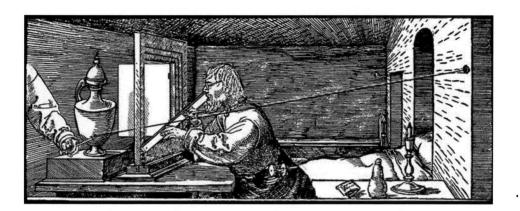

PETER DAVIS

Peter Davis studied at the RCA, is a practising
artist and lectures in Design Culture at the
University of Plymouth.

Drawing a Blank

When I started thinking about this piece, I immediately had a sensation of what it feels like to participate in drawing. The sensual quality, the honesty and its endless possibility, lying on sand and leaving your imprint. Two images, one of the De Kooning drawing, erased by Rauschenberg and Yves Klein, blowing gold leaf into the River Seine in Paris, have been ever-present in my mind. What was apparent was the complexity of the task. But also a thread of what it means to me personally, as a western male, living in a multi-diverse cultural system, trying to make sense of what it is to be alive. I have always thought that drawing is linked poetically to the heart.

Drawing a Blank

The title of this piece is, I expect, predicated by the old academy's notion of drawing, being able to produce 'truth', a dodgy word at the best of times. I suppose there is no truth to drawing, except for the truth of the moment. The title is also paradoxical or a conundrum, because some drawing cannot be described in words. Drawing is analytical but it is also expressive in its own right; it has a duty to bear witness, not simply by making a representation of something but by taking things apart and reassembling them in a way that makes new connections. Drawing is magic, drawing can be a necessity, drawing is an attempt to fix the world, not as it is, but how it exists within the individual or individuals' mental diagrams. Drawing is a mirror, a window, a door and a lens, which can be looked at in either direction. It is in essence a truly experimental process.

It is a process which has no cultural barriers, no political or national boundaries, a process used by young and old alike, although perhaps not used enough. Yet with all the contradictions of these characteristics, it's not surprising that in the West the story of drawing remains obfuscated and occluded in the extreme. I expect this is for several reasons, but one surely must be the nature of the process itself. The meaning of things lies not in the things themselves, but in our attitudes to them.

Essentially and in its purest manifestation, drawing is about direct contact with form, a conjuring trick with no audience. It is also about the intention of the individual, however that may become evident. It can be a mirror to the soul. I know there is a tendency to get carried away by rhetoric and eulogise the sublime in drawing and why not? It remains, in these days of the manipulation of truth; 'Pumas are shoes'; a constant non-corruptible form. To make a cricket analogy, not that I am an authority, it is a process that can last five days and still end up a draw. Forgive the pun, please.

Time

It would be impossible to do justice to such a complicated subject if we did not look at some general historical facts and their development. In its broadest sense drawing includes all kinds of graphic notation from the most fragmentary to the most highly finished. It is usually executed by marking directly on a surface. Drawing can be used to record what the individual has seen, or it may be a visualisation of imagined forms. It can be a graphic symbol, a plan, and it is recognisable because it has commonly understood meanings. The history of drawing is as old as human beings and has been used throughout civilisations to depict and illuminate our existence. In the West the Middle Ages saw the rise of illuminated manuscripts, the Book of Kells, the vigorous drawings in the notebooks of Villard de Honnecourt. The Renaissance bought us pictorial realism and laid the foundation for practice in the arts. The advent of the study of perspective, medicine and anatomy, bringing us in hyper drive to the twentieth century, where through the advent of new notions of language, amongst other things, new ideas about drawing began and there was a blurring of definition.

I imagine a shopping bag, full of the characters that could populate these pages, in fact more like a bag of knitting. One could postulate about the dynamic of gaps: Where is Kant, where is Descartes, where is Wittgenstein and Klee, etc? I am not here to produce or trace a historical through-line, but maybe to evaluate a range of interesting approaches to a way of looking.

I expect we all have memories of drawing from a very early age and how our own understanding of drawing has changed in adulthood – our own first drawing, the intricacies of Leonardo's mind mapping, Japanese calligraphy, watching Picasso draw on glass, Yves Tanguy's drawing machine, Giacometti, Beuys, Andy's shoes and not forgetting Rolf Harris, Tony Hart.

The intrusion of your life drawing tutor, who effortlessly drew all over what at the time was your pride and joy, seemed to change the nature of drawing for me. It was the necessity for ownership, for control, for the time when there is no time.

Memory

While an undergraduate at Cardiff, two friends and I went to see Captain Beefheart. We had to get there early because Martin was completely obsessed with the man. Desperate for the loo, we were all taking a piss when the great man entered. After the initial embarrassment and then genuflection, the man himself retired to the cubicle and continued the conversation behind closed door. 'What are your names?' 'Where do you come from?'etc. When he finally emerged, poor bloke, Martin insisted he

sign various parts of his body, and he did this graciously and left. Martin, overcome with emotion, felt he had to sit on the loo the great man had used. There was a palpable silence and then a scream, we rushed in to see the back of the door completely covered in drawing with a dedication to us; needless to say that door remains missing to this day.

Several things struck us at the time. Obviously we had got a result, but on a serious note, was the powerful nature of drawing, its poetry, its cultural worth and the extraordinary power of communicating directly. It was also about the truth of a time linked to a memory of a time; do we remember the concert? Vaguely, do we remember the circumstances which produced the door? Most definitely!

So what do we have here, discursive as it may be? There is an interest for me in the notion of truth, there is an interest in the notion of memory and ultimately there is an understanding of what drawing can be.

History

In 1914 Le Corbusier wrote a report on the state of drawing for the Swiss government. This report resurfaced during 1919 in France and he had no doubts, being the man he was, about the state of drawing in primary and secondary schools. 'Drawing is a language,' he said, 'a science; it is a means of expression, a means of transmitting thought. What is the usefulness of these acts for life, for each person, for artisans and artists? It is the means for copying an object in order to perpetuate image. The result constitutes a document. This document should contain all the elements necessary for evoking the object, not only as an ensemble, an effect, but also with the exact measurements and possibly its colour and materials. It is the means for transmitting integrally its thought to whoever, without the aid of written or verbal explanation. The means for helping its proper thought to crystallise, to take shape, to abandon yourself to the investigation of taste, beauty's expressions and emotion.' Drawing and art then, were not identical. Drawing science was of use to everyone; the same could not be said of art.

Le Corbusier is interesting for many different reasons and before the groans of, 'Oh no not the Villa Savoie', he was a tremendously complex and contradictory character: an artist, a visionary, a man of tension and dubious political belief.

He gave no reference for his study about drawing, but we have heard it all before. What is interesting are the links to the language of industry and the link to language in general. It is

a constant theme of his writing throughout the twenties. Purism or dubious political belief, whichever side of the fence you choose to come down on, is of cultural worth. During 1927 and 1928, Le Corbusier was working on the Villa Savoie in France. It is a classic and early example of the International Style. Unlike many of his other buildings, it stands

alone, set in its own grounds. During its construction, he made a drawing depicting a man working his frustrations out on a punch bag, while his partner looks on from the terrace. An image, which describes a time and a belief, it remains one of those images, if you push through its first impression, with enormous connotation, not one of the round window approach. Man is a geometric animal, man is a spirit of geometry; man's senses, his eyes, are trained more than ever on geometric clarity. He would try and bring full consciousness to modernity, cutting to the bone, nature, industry, man and machine; he had obviously been reading *War and Peace*. For all this talk of progress, the line failed to change.

Trawl

In the twentieth century particularly, scientists have struggled to find ways of representing unseen worlds as artists have, each involved in a different discipline with different outcomes, but with a common bond. Where does science figure in the world of the drawn? Notations, scrawls on margins. Galileo's drawing, beginning to think along the lines of free-falling into a vacuum. Descartes' scribbles realising a step into geometrising our view of the physical world. Minkowski's sketches of time-space diagrams. The teacher of Einstein, whose little men on bikes dawdled on their way to discovering the Theory of Relativity. Minkowski said of Einstein 'He was always cutting lectures, that boy, too busy drinking coffee and doodling.' Poicare's love for the back of envelopes. Paul Virlio endeavouring to draw speed. Edward Wilson, the world's leading authority on socio-biology, mapping ant movement. All these characters described themselves as visual thinkers; the idea was visual before it was anything else.

There is one character that I think embodies my own interpretative and flexible notion of what drawing can be and that is the oceanographer Alistair Hardy. He was born in 1896 and during the Great War was a camouflage officer in the Royal Engineers. He studied Marine Biology in Naples and later extended his research interests to trawlers in the North Sea, working particularly on the history of the herring and its food plankton. He built up a huge body of research and developed unique survey methods to study the ever-changing plankton movement over wide areas, using his automatic sampling machines. In 1938 he extended this activity to cover the Atlantic. Commercial trawlers towed gauze strips, which were dropped, allowing the plankton to embed itself. This culminated, over many years, in a complete record of plankton drift across the Atlantic. In addition to his researches on the distribution, vertical migration and luminosity of marine plankton, he studied what he called airborne plankton: the movement, through the air, of large populations of small insects, which forms the food of swifts and swallows. He did this by flying kites with collecting nets, flying to 2,500 feet, getting many ships to use nets at their mast-head when over 100 miles from land. Sounds like an extraordinary performance. So we

have a complete record, which stretches the Atlantic, of not only the submerged plankton but also the airborne record of small insects, a natural record, a natural drawing, a time tag of movement, a submerged and aerial Christo.

Tag

I know this takes a leap of imagination in terms of how this could perhaps be considered drawing. How can an image, at times very unusual, appear to be a concentration of our perception of an entire psyche? How, with a lot or a little preparation, can a singular lucid event constitute an unusual poetic image? How in the hearts and minds of others is there a reaction, despite all the barriers of common sense, all the disciplined schools of thought, sometimes content in their immobility? Drawing is in that zone when originality is impregnated with potentiality, imagination as a humanising faculty, human impudence.

As I have been writing this I have felt that I have not done justice to the many individuals who could have been within these pages. But yet again, how can one give emphasis and dignity to their endeavour without contextualising the practice away from its raw sensation? Drawing has been a distinct form for centuries and as I have previously intimated, when it has been analysed, it has always remained elusive. It has changed and evolved because of those who use it; the pencil or whatever medium is used has remained penetrative, salient and poignant, and I am sure it will continue to be so. What perhaps remains is the question: Will our way of life increasingly call upon the realm of the drawn or any direct action, where there is no separation, no fiddling with meaning, to articulate and clarify our place in the world? Will questions of consumption, identity, the material culture, be better articulated through the eyes and hands of our children, whose notion of space, movement, truth and place will be very different from our own?

Edward D. Wilson, *Consilience, The Unity of Knowledge*. Abacus, 1998.

Alistair Hardy, *Great Waters*. London: Collins, 1967.

Arthur I. Miller, *Genesis*. Copernicus, 1996.

Edward O. Wilson, *Socio-Biology the New Synthesis*. Harvard: Belknap Press, 1975.

Charles Jencks, *Continual Revolution in Architecture*. Monacelli Press, 2000.

IAN MASSEY

Ian Massey has a degree in Fine Art
Printmaking from Exeter College of Art and
Design and a Master's in Graphic Design
from Manchester Polytechnic. He has a
long track record as a freelance
illustrator and exhibits his personal
work on a regular basis. Interviews
and reviews written by him appear
regularly in the Association of
Illustrators journal. Ian is Senior
Lecturer in Graphic Design at
Nottingham Trent University.

A Dialogue with Joanna Quinn

Joanna Quinn is an animator of renown. Her work has been applauded at film festivals internationally, and her many awards include a BAFTA, for her 1998 film 'Wife of Bath'. Beryl Productions, the company she set up and co-runs with Les Mills, produces films and commercials with an emphasis very much on drawing. The tools of the trade are traditional ones: predominantly pencil on paper. Joanna is insistent that the quality she requires can only be achieved via this particular medium.

My conversation with Joanna Quinn took place at the Beryl Studio in Cardiff.

Viewing your show reel, there's a very evident stylistic change apparent in your drawing, from the award-winning student film of 1986, 'Girls Night Out', to say, 'Elles', made six years later. The move is from caricature to something gentler, more realistic. To what extent was that change pre-meditated?

When I did animation at college I wasn't absolutely sure about the contexts within which it would be placed. As a child I was always good at drawing cartoons, but I also used to enjoy drawing realistically. So I would draw cars for instance, from observation, but the thing that would make me popular in the class was drawing caricatures, funny drawings. And because I ended up doing animation, I just thought that it had to be funny, fitting into that idea of caricature. Later, of course, I went to film festivals with 'Girls Night Out' and discovered that animation isn't cartoon; it's art. I realised that what I really wanted to do was try and draw properly; have fun with drawing, but make films that would not just exploit the cartoon side of things. I wanted to make an art film whilst retaining the humour.

So would it be true to say that you started to take your work more seriously from that point?

Yes, it was a conscious effort. I made 'Girls Night Out' at college and I didn't really think about what I was doing, I was just having fun. When it was a success it was all a bit shocking. And then we got money to make a film, and as soon as the notion of money entered into it, because I'd never earned money before or knew what money meant, I thought I had to do something 'professional'. And of course it went wrong. I'd enjoyed the freedom of 'Girls Night Out', but I thought, 'I can't work like that. Everything has to be neater and tidier.' So of course the next film, 'Body Beautiful', ended up quite sanitised.

In what way?

I thought it was too clean and I cut corners on some of the animation, some of it was a little bit staggered. I felt in the end it lacked exuberance. Also it was too long, because I was thinking that a longer film is a better film and of course that's wrong. However, although there were negative things on the art side, there were positive things such as learning to work with actors.

In that film too the drawing is very much within the realm of caricature isn't it? I'm struck that in your later work, the figures have a fleshy, fleshly quality reminiscent of those of your first films but that stylistically they are more realistic. There's more sense of anatomy and musculature in 'Wife of Bath', for instance.

Yes. In fact my grandmother was dying when I was working on that film. So the hag in it is very much based on my grandma. I know it sounds awful. She was dying, wasting away. She was really old, and I was looking at her emaciated body. The human body to me is fascinating, and looking at her, and also doing this film at the same time, I was able then to piece the two together and explore the idea of ageing.

Although your work has become gradually more refined, something of that early rawness still remains. There is always a particular surface energy. The screen is like a continuous drawing in flux, with traces of erasures and changes within the process left evident. And the surface shimmer created by those trace marks enlivens the whole screen; not just the figures, but the backgrounds and blank spaces as well. Of course, the 'trick' of animation is to make an illusion of movement via a series of static drawings. But in your work, whilst being drawn into an animated narrative, we're also continually reminded that what we are looking at is drawing. The evidence of erasure and change serves as an underlying commentary on the physical nature and organic process of drawing.

Actually I find that if I don't include those background marks it's somehow deadened; the spell is broken, and you're then looking at a picture, not entering a world. But I have tried to calm down that aspect because it can be a little bit hard on the eye!

Of course, the other thing is that your line has become more confident over time. Your work is essentially linear, line describing form and movement.

Yes, I've learnt over the years to be confident with my drawing. When I start a drawing I know what I intend to draw but I let the line take me in other directions and create forms that I hadn't thought of, especially with the human figure. I love finding different ways to bend the head back or twist the torso just by using line to feel the form. Suddenly I'll see something dynamic and decide to strengthen the line a bit. This is why my drawings have so many lines on them, and why I don't like rubbing them out. It shows my exploration of line, my enjoyment of mark-making. I often have the sensation of not being in control of my hand, that some other force is guiding me, which is probably a common sensation for artists who are totally at ease with a particular medium. My drawings are very loose and yet very considered, and this is why I'm so suited to animation, because animation is all about loads of drawings, lots of problem-solving.

Can we talk about your working process? You begin with a concept. Les Mills works on this aspect with you. To what extent is it collaboration?

Well it is collaboration. Sometimes we both come up with the initial ideas but usually it's Les. He then explores the ideas further and writes the scripts; we've been working together since the early 1980s. The thing is, I'm very conservative, quite staid and anxious, worried about failing. Desperately wanting to be challenged, to stretch myself, but I do find it quite hard to experiment. So working with Les is really good because he's incredibly open-minded. His ideas are much wider and much stranger that mine.

After we've discussed the ideas and he's written the first draft of the script, I then respond visually. Sometimes I say, 'God, I can't draw that' and he says, 'Maybe you're thinking of it in the wrong way, maybe we could do it this way.' It's really painful, actually, when we work together, because he gets really excited and I get really negative, saying, 'Well, that's not possible, that's not possible!' But as I'm saying it, I'm sort of accepting that it will happen. And we end up agreeing! But it is a bit of a fight because we are so different. In fact, we work really, really well together.

How do you evolve the characters? Do you draw initially from imagination and memory?

No, I tend to avoid memory and imagination. I'm not very good at that! I use photographic reference. If I'm drawing a particular character then I'll go out looking for that character, or try to work out what sort of hair he would have, what sort of clothes he would wear. So when I'm out walking I'll perhaps see someone and think, 'Oh yes', then go back and do a drawing of someone with a certain kind of curly hair or something. So you're piecing it together like a jigsaw. I've recently started to think of character designs for the new film, 'Dreams and Desires'. Les has written very rounded and funny character descriptions which I now have to match visually!

What kind of photographic reference do you use?

Every now and again I go through magazines and cut out all the interesting faces. I've got big folders of those which I refer to.

When you've developed the characterisations, how about the actual movement? How does that evolve?

I think to capture your initial idea on the storyboard is the most important thing. What I normally do is draw the characters randomly and then put a box around them, or draw a box but go outside of it. I try wherever possible not to put any constraints on the initial idea, and be as free as I can at that stage, because those first drawings are the most lively ones, and they sum up what I'm trying to do. Then I take each storyboard frame, blow it up on the photocopier, and make it a size that's nice to work with. After I've captured the moment and energy within the drawing I then look at it critically, often using the mirror to check the perspective. Looking at an image in reverse is like looking at it with a fresh pair of eyes, because you use the other side of your brain I believe. I make sure that every key drawing is as good as it can be before I move on.

When I was looking at 'Wife of Bath' I was reminded of Damier. Your film 'Elles' is based on a Toulouse-Lautrec painting. This made me wonder about the influences that have come to bear on your work.

Well, Daumier influenced me greatly. I always think he'd have been an animator actually, given the opportunity, because his drawings are so full of movement.

Given that your work is so obviously about form, has sculpture influenced you, or do you have an interest in it?

I did actually want to do sculpture about ten years ago. I fancied going to night school or something. It's funny, because I'd never really thought about sculpture until I saw some small late bronzes by Degas in Paris. Sculptures of ballerinas, very much about movement.

Was animation something that you want to get involved in from an early age?

No. I wanted to do photography, in fact. Before that, when I was about 13 or 14, I wanted to be a comic strip artist on 'The Beano'. So I went to their offices with a portfolio. They were very nice to me and said perhaps I should go to art school!

You went to Goldsmiths.

Yes, for a foundation year. I did some lovely big paintings which I thought were fantastic; they were probably bloody awful, but I really enjoyed the experience of doing them. I was trying to make them sort of sketchy (gesticulates large arm movements) and they said, 'No, no, no', because the paintings weren't very carefully done! But I wanted to capture the energy of a drawing in painting; that's what I enjoyed. I'd enjoyed the painting so much because it was new to me, and it was so hard for me to do. But the tutors said, 'Oh no, you're definitely a graphics person!'

After Goldsmiths Joanna joined the BA Graphic Design course at Middlesex, where she worked in illustration and photography. But it was an initial experiment in animation that created the most excitement for her. She began by drawing animals and used those as source material for a short animation.

I just remember seeing these legs move, and it was so exciting. I think the best thing was that everybody was around me going, 'Wow, that's really good!' (laughing). I'd found my niche then. There was also a feeling that it was my game, there was nobody else doing it.

You've obviously come a long way since your first student film, to a situation where you now head a team of people here at the studio. You now produce television commercials as well as your own films. How have your role and working methods changed over time, within all of this?

Well, my first films were totally animated by me with no help except with the colouring. When I started work on 'Wife of Bath' I knew that I had to find help because there was too much for me to do on my own. I am so particular about the quality of line that I just couldn't imagine finding a clone that would draw exactly like me. I gave people animation tests and, of course, I didn't find an absolute clone, but I did find people with different skills. I decided that I would do all the key animation drawings and use an assistant to do the in-between ones. This worked really well, but, of course, the in-betweens looked different to mine. So I took those drawings and worked into them until I felt completely satisfied. I absolutely loved working in this way. Where commercials are concerned, it's a fast turnover. Currently we're working on the latest of our commercials for Charmin. We can be working on four adverts at the same time, and I can't possibly animate

all of those, even if I'm doing key drawings and giving out the in-betweens. I'm animating one of the ads at the moment, but usually an animator called Mike Coles animates most of the spots. So he'll do the animation, and we'll send that off, for initial client approval. And what I'll then do is I'll take the first drawing and any significant drawing and then I'll put it into my style on another sheet of paper. That then gets in-betweened by somebody else. I'm only really involved in the storyboard, the staging of it, and blowing the storyboard up to create layouts that Mike will work from. So he does the animation, which the client looks at, and then I come back in to do the final line over the top.

So Mike produces what is effectively a kind of rough cut, and then you restyle the drawing?

Yes, I make it look like I did it in the end. And that works really well. It's called 'clean up', going over the drawings, although it's not actually cleaning it up, it's almost messying it up. But it is about refining and making sure the characterisation is absolutely correct and everything's the right size and so on. A little team of us work closely together on that. The thing is, with the increased volume of work certainly over the last four years, my role has had to change. I've learned to delegate and feel totally comfortable with the system that we've created. The studio has a core team of about seven, which grows to perhaps twenty when we're busy. Importantly, I am only in this position now because the people at Beryl are so highly skilled and motivated, and we all understand each other's strengths and weaknesses. Each person has different skills and plays a different role.

I'd like to ask you about the themes in your films. Your CV includes what amounts to a statement of intent, that the aim is 'to produce high quality, accessible animation which is observationally based and exploits both universal and personal themes, specifically in relation to strong female characterisation'. Women are quite dominant in your films, often to the detriment or humiliation of men. Has that come out of any particular personal experience or sense of politics?

Well, I think a lot of it stems from being brought up solely by my mother and seeing her strength and resilience and her ability to laugh in the face of all these dreadful things. My mum was a teacher, and she had a pub job as well, at night. So sometimes she didn't come home until about one in the morning, and then she'd get up and go out to work again. My dad left her when I was about seven. She struggled to hold things together, but was terribly humorous at the same time. She would just laugh and not put any of her problems onto me. Although obviously I did feel responsible, but she never tried to make me feel awkward or anything.

So that's where this theme stems from.

I would expect so. Also, when I went to the Annecy film festival for the first time in 1987 I saw wonderful films, but some bloody awful sexist films too. There were people laughing at stuff like this. I couldn't really believe what I was seeing. And then I thought, 'Gosh, you know, I do have a responsibility, to make films to try and redress the balance.' More recently I think my idea of the men and women thing has shifted

somewhat. They're all as rounded and believable as each other now. I was quite angry when I was making those earlier films, quite political. Now I'm over forty I couldn't care really! (laughing) Who cares, sod it, and leave that to somebody else! With the film we're just beginning to work on, 'Dreams and Desires', even though the character Beryl is again the protagonist all the way through, we're having so much fun with it because we're really getting into her husband and other male characters in a much more rounded way. Before her husband was a couch potato, but now he's turned into this wonderful person who always wanted to be a vet, but never had the opportunity. So we thought it would be fantastic to have little children knocking on the door with hamsters and things so that he's always in the background mending animals (laughing). And he was a wonderful dancer; the only reason they got married was he was a wonderful dancer and kisser. He was the catch!

There are distinct differences between your personal work and the commercial work you're engaged in. I'm struck, for instance, that the Charmin commercials are much more restrained than your films; they don't have that surface shimmer that we talked about.

The agency approached me because of that look. They wanted it to look 'rough' and lively, to make the commercials look different. But, of course, Charmin is a hygiene product and you couldn't have chosen a dirtier animator than me. So I had to make it cleaner because the client would just ask why was it so dirty.

We've got a technique to keep it clean, matting out dirty areas. It's all composited, so everything's broken down into layers. As soon as you take it into post-production they just clean everything, everything's polished.

There are other constraints. Attempts to experiment with or further develop storyboards presented by the client have proved frustrating.

Ultimately they're going to turn round and say, 'Erm, no, can you just do it like our storyboard?' We've learned to stick closely to the client's storyboard. We put it into our own drawing; maybe change an angle here and there. So at storyboard stage we copy exactly what they've done, unless they say they're a bit unsure about something. But you tend to just copy what they've asked you to do and then animate it. It's just a formula now, which we stick to. We still like to challenge ourselves with the ads. The one thing that work experience people all say is that they're surprised at our level of acceptance; even though it's a commercial job, and even though we get frustrated by the people we're working with sometimes, we still want to do the best job we possibly can. It's how you value yourself and your art, and if somebody pays you well for a job, you do it well. If somebody pays you nothing, you still do it well, because if you've agreed to do something you should do it 110 per cent.

So any element of compromise isn't in the animation itself but in having to adhere to ideas which you perhaps feel could be improved upon?

Yes. But it's important to learn from everything that you do. Everybody

here takes pride in doing a really good job. It's funny. I was on 'Woman's Hour' about selling out to commercialism or some such. But I see it as a really positive thing. The commercials have enabled us to get the studio going. Also, you're given such tight deadlines you have to think on your feet, and it's enabled us to use people that perhaps we wouldn't have known about before. And that's great. You discover all these really talented people, who are fantastic to work with. In that way it's just been wonderful, because we've got this big team now.

Joanna showed me a group of drawings made for the Charmin toilet roll commercials. These are stored chronologically in pocket files. The initial drawings of the bear character for the commercials are based upon photographic reference, and are rendered in a fairly realistic manner.

We started off by trying to work out what it is that makes a bear a bear. When you draw you take for granted, don't you, what something looks like? You think you know, but soon realise you don't know what it looks like! It's that re-learning, going back to the original thing and then starting to take things away from it; trying to find that essence of what makes it what it is.

Photographic reference is used purely for characterisation. In the actual animation the reference is all from life.

Even if I'm animating an animal I can get somebody to enact a movement and draw it. The thing is that you've got the skeleton there, you can tell where the weight is. With observation from life you've got the truth. You can bend it afterwards if you want to.

As we leafed through the Charmin drawings, Joanna described the process of simplification, of trying to get the characterisation right. The overall process of hitting upon the exact drawing style took approximately three weeks. At a certain level of simplification the client decided that they wanted the character to be 'more cartoony'.

At this point I was hating it; I didn't like the drawings at all. I think at this point (turning to another drawing) I suggested they use somebody else, because I really didn't think I could do what they were asking me to do. Then I did these (another sheet) and they liked them.

Once the exact manner of drawing is established, it is important to ensure stylistic continuity.

Even now I still have to have a sheet of definitive bear drawings to refer back to, because he went all cute and round at some point and the agency kept asking, is he changing? And I said, 'No', and then, of course, looked again at the old drawings, and he had changed! So we have a character sheet for reference for the drawings.

The work which Joanna and her team produce is defiantly traditional in its values. Quality is paramount and takes time. Technology is used where deemed appropriate, but never at the expense of the desired standard. For instance, software that enables colouring in to be done on screen has been tried, tested, and deemed unsatisfactory.

We've actually gone completely back, and do everything in layers. It's all hand coloured on frosted cell, which seems so old-fashioned that people laugh at us. We shoot each layer on film and sometimes we scan, but I like the quality of film. Then we composite it digitally. So you've got the lovely hand-drawn, crafted quality, with the grain of the film. It feels more organic.

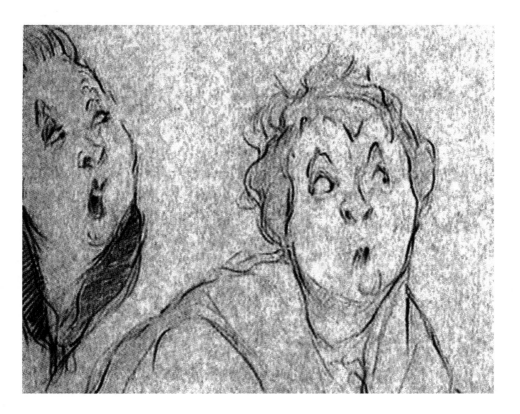

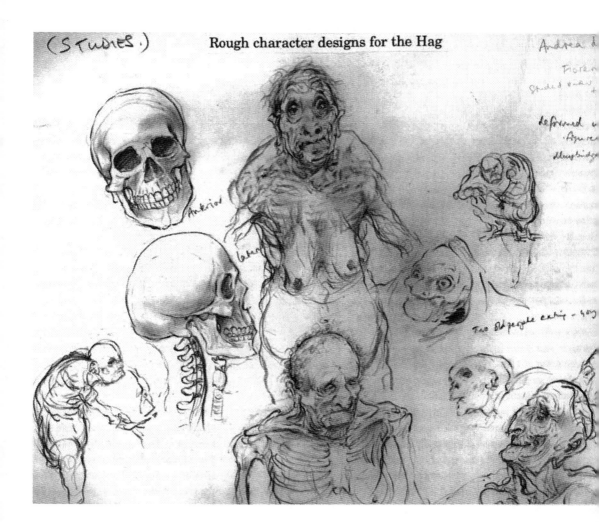

Courtesy of Joanna Quinn. Drawings for the Wife of Bath and the Old Hag.

Drawing – My Process GEORGE HARDIE

This is an attempt at describing how the jobbing illustrator occupies the centre of a web of ideas and experiments in spite of being interrupted by clients' individual requirements. This web is informed for me by observation, collection and classification, by what is to be communicated to whom, by a complicated set of personal rules about making pictures and drawing, by what ı like and don't like and, of course, by what ı am able to do and what I'm unable to do.

If any of these thoughts or anecdotes appear immodest, please remember that ı am only describing what ı am trying to do and that ı make no presumptions about the success of my endeavours.

Drawings for print serve three separate purposes: as a mnemonic (a visual list) of possible approaches, as a way of discussing with the client all these approaches and how they might appear in the final piece and lastly as a way of building a prototype for the printer. I find it important to make this an enjoyable and mutable process, and to invent ways of avoiding the boredom of making neater copies of neat roughs.

Hitting the paper

There's a military aphorism that 'No strategy survives in the face of the enemy', which seems to perfectly describe the moment when an idea has to be put onto paper.

Drawing begins with a strange leap: from what is quite often a fully realised image in the head onto paper. This leap is not usually successful – everything needs to be changed radically and often one has to return to the head before making a new start with the hand. Drawing in the head doesn't work very well; drawing with the head is essential.

I find that tiny compositional drawings made with any implement, and in my case surprisingly often on a train, help with this transition.

After a selection process, the chosen image is grown to full size with a photocopier, which might preserve any freshness, but is principally to ensure that it fits the space and will work at the given size. At this point, composition and size decided, begins the long process of refining the image which has to be a balance between the arrangement of the parts within the space, with considerations of whether any idea is still being delivered. In my case some of the parts might carry a symbolic meaning or involve the audience in a game. Ensuring that the messages sent are the messages received is difficult: the audience being able to recognise what is drawn is central.

I was told by a student in dance that the first stage of any group criticism of a performance involves carefully describing just what they have actually seen, giving no heed to what the performance might mean. This scheme works just as well for drawing and illustration: one can be dismayed by how illegible a drawing can be before being further confounded by viewers' interpretations of its meaning.

Limitations

I admitted in a lecture that I struggle to draw, having no academic ability and not being able, for instance, to achieve a likeness of anyone. A recurring nightmare for me is that I witness the theft of an expensive computer at the university. The police arrive and I'm asked, 'You're an artist, draw us a picture of the burglar.' Collapse of stout party. A voice from the audience. 'Don't worry, George, you'd be good at drawing the computer.'

I am limited by my problems with drawing people but have worked out various ways around this. I'm full of admiration for Edward Bawden's decision, made half way through his career, that he must learn to draw people properly if he were to succeed as an illustrator.

Unlike songs in a musical, I *never 'feel* a drawing coming on'. Almost every picture I produce is made to order or to express some idea of my own (even these are 'graphics without clients' rather than for the gallery).

Drawing from above

'Use the difficulty.'
Sir Michael Caine

In my search for ways of drawing that would carry ideas and still look good, I began by using pastiche and parody, but these are really just ways of not drawing (and can steer perilously close to plagiarism). I remembered my early lessons in geometrical and mechanical drawing (an alternative class for those who were not up to Latin) and particularly the isometric and axonometric projections. These provided a system for drawing pretty much anything and gave me a tight set of rules to obey or subvert. The systems automatically involve figure and ground, and how objects relate to the edge and frame has become a personal obsession. As a style, any projection, with its inherent 'wrong' perspective, is intriguing. Mechanical drawing lent itself both to drawing things mechanical and technical, and making audiences look twice at things natural. With the axonometric one can draw three sides of an object in one picture, and the overhead view instantly provides drama and tension. (As with a Hitchcock camera angle, rather than the action viewed from the back of a theatre through the frame of the proscenium.)

The search for a style of drawing is never as interesting or important as the search for a way of observing, seeing, or thinking. However, making recognisable images at any particular stage in one's career is useful, and with intelligent and adventurous clients, it eventually becomes possible to experiment with a range of drawing methods, each appropriate to the task in hand and the idea involved.

Although much less strict and geometrical, my affection for the aerial view still persists and is almost a habit. I found myself standing directly beneath the clock at Harvey Nichols making notes for a magazine

illustration. Nosey-parkers looking over my shoulder at my drawing were rewarded with a bird's eye view from above the clock.

A student at Brighton described how, as a child on holiday, visiting a village for the first time, her father would find the highest spot and the family would make bird's eye drawings of the place, the best way to understand a new environment (and subsequently for that student a great way of controlling a complex story about a village).

Maps, charts and plans are another whole subject but represent one of the best ways of drawing intentions. It is easy to describe some motorways as 'beautifully drawn' as one drives along them through the curves of the landscape. The plans for them don't have to be beautiful except as imaginations of the future.

'You should be suspicious when you see a straight line on a map.'
Peter Barber, British Library

Unfortunately most politicians only draw on maps.

In a corner

In the search for the 'perfect', carefully arranged, non-gestural drawing the corner presents problems. The first will be well known to anyone interested in drawing neatly. Does one draw past the corner in black and then come back and correct the overdraws with white paint or by scraping with a blade? Or, which never works for me, does one try and get it right first time? With axonometric projections all corners of objects involve the meeting of three lines. This is very difficult to perfect if the line has any thickness. Sometimes for technical reasons my drawings are remade with a computer and when I check them it always the corners that are wrong. If people are not very experienced at geometrical drawing or are trying to use it merely as a surface style, it often shows in the lack of attention to the fitting of the corners to the edge. (A sentence in which I put myself on a crumbling pedestal, but without falling into the trap of accusing anyone of copying a style which I merely borrowed off the peg).

The Web of Rules

Each project entangles the illustrator in a complex of rules: rules of function which might come from a client; rules of reproduction; rules imposed by the audience and context; rules governed by the deadline. Any definition of 'jobbing' must include the word 'deadline'.

There are rules that are more personal: which drawing implement or technique is to be employed? Is line to be used? Line of varying or even thickness? Line of what width?

Will the line be perfectly mechanical or broken by the surface on which it is drawn?

There are rules, some them negative, based on the illustrator's body of work, tastes and abilities: rules of purpose might relate to the illustrator's work as a continuum; rules concerning not being able to draw something; rules concerned with not wanting to draw something; rules about avoiding one's own clichés; rules about colours and edges and shadows and words and corners; rules about making the game supplied by the client, context and illustrator even more difficult by imposing just one extra rule.

Although perhaps not all considered consciously and not often evident to the audience, these rules must be coherently and consistently deployed within a picture and particularly in a set or series of pictures. These rules, not whimsy, make a style.

A simple way of understanding the complexity of this web is to imagine commissioning somebody to make the final image in a set of ten drawings, the first nine all by another illustrator. Better still, imagine writing out the list of rules and decisions already made as a design manual to enable anyone to provide the tenth drawing. Imagine being in charge of continuity.

Even a simple decision to make a set of ten completely different images would be a tough game to play.

'I'd as soon write free verse as play tennis with the net down.'
Robert Frost

A favourite brief, and one that is full of wisdom (and rules) about how to think about illustration and its real role. Pictures are required for *My First 80,000 Words* – a child's first dictionary:

… You must choose a word, the one you like best, the word you consider to be your favourite… you must keep in mind that this dictionary will be directed mainly towards children and adolescents… however before choosing a word that is simply funny, it would be better to be as honest as you can and choose a word that really means something to you. Plus instead of choosing a word that brings to mind an immediate image, it is better to choose a favourite word and not give up on it, even if it takes some thinking… In our opinion, the main interest… is to take a series of special words out of context – words that have become special because they have been individualised – in order that the reader approaches them from a different point of view or takes notice of them for the first time… The image proposed by the illustrator may approximate the definition or it may dance around it. But we must never forget that an illustrator is not someone who must decorate a book but through his or her images, must 'help us see' and necessarily express an opinion…[2]

Gesture

Wayne Thiebaud, the American artist, described painting a letter O as a

junior in a sign writing shop. The project was not going well. His boss advised him, 'You're looking where you're going rather than where you want to be.'

Great moments in learning to draw.

Although I am obstinately non-gestural in my approach to drawing, many of the lessons learnt are about the physicality of making images. Here is my list:

Realising that you can use a ruler and rubber and that you can mend a drawing. (1964- Pre-diploma)

Making a drawing with dirty hands without transferring the dirt onto the paper. (1967-BA)

Discovering that curves are better drawn from the inside. I suppose that the way one's arm and hand work is about gesture, but making a curve with a French curve (or a mouse?) obeys the same rules. A great follow-up is realising that you are allowed to move the paper. It is at this moment that it becomes clear that one is making a drawing which begins to be a new object, as opposed to copying or rendering an existing subject.[1]

Buying my first rolling ruler. (1970)

Using a light box for tracing. (1975)

Finally realising that still lives are things you arrange before you draw them and again whilst you draw them. (1980)

Buying a really complete set of ellipse guides in all degrees and all sizes. (1982)

That if the drawing is to be disseminated, by any means, there doesn't really have to be an original with intrinsic value. (1986)

A fixed work light means that you have to move your drawing tools, your chair and the drawing to the right or left to avoid casting the shadow of your hand or your ruler. My most recent breakthrough is buying a properly adjustable light. (2002 – after 58 years of drawing, I offer this list as a shortcut for others.)

At the end of a lecture a student asked, 'What size are your drawings?' I replied, 'Increasingly big as my eyesight gets worse.' The next day over lunch I was asked, 'Do you ever make very large drawings?' I replied, 'As my stomach gets bigger I find I can't reach far enough across my work table to make large drawings.' It seems retirement might be just around the corner.

Decision

Drawing for me should be definite: with all decisions made. (I'm rather fond of lying to make a point: artifice is a favourite word. For a number of years I risked telling students that it was no accident that design was about making decisions as the two words have the same origins.) A

definite final line is terribly risky just because it can be definitely wrong. The alternative, a structure of tentative lines that bracket the target, reminds me of 'hedging'. My English teacher forbade 'hedging', a word he used to describe writing a word so unclearly that it would cover two alternative spellings.

Somebody once said about my work that 'it looks as though it's always been there'. This was intended and received as a compliment and I wish I could remember and thank whoever

said it. The phrase describes a way of recognising the point at which a drawing finally goes 'clunk'.

Nowhere is this 'clunk' more important than in the area of pattern, figure and ground. The visual game I enjoy most is creating tight, almost tortured, arrangements of objects into two-dimensional patterns, but so the objects appear to be both three dimensional and to be sitting on a common ground. This is difficult but as the framed sampler in my studio says, 'Graphics isn't meant to be easy.'

Observation

'Drawing is a way of looking at something for longer than you would have thought possible.'
Fred Baier

Sitting next to a counsellor at dinner one night I was asked, 'What do you do?'

I replied that I was a freelance graphic designer, perhaps more of an illustrator, and that I taught and lectured at art schools. She told me that these were really just titles, names and even ranks and asked again, 'What do you really do?' I wasn't able to come up with any kind of snappy answer at the time but a month later I retitled a lecture about working methods and the role of the designer/illustrator 'Noticing things and getting things noticed' – which is what I really try to do. I don't find drawing particularly useful as a method of recording the things I've noticed – memory, objects, lists and notes work very well. However, the moment whatever it is I've noticed becomes appropriate to pass on to anyone else, the whole exercise becomes visual and involves all kinds of drawing.

'He was a man who used to notice such things.'
Thomas Hardy in Afterwards, *a poem in which he describes how he wished to be remembered.*

Noticing things is hard work and of no use if it is merely serendipitous. There can be magic to support this activity.

'There is something almost comical about the ability and willingness to find references to one's own passionate preoccupation in whatever one reads, and the truth is that pertinent things run into one from all directions, they are played into one's hands almost in the manner of a procurer.'
Thomas Mann

'Stories are told to people who tell stories.'
Paul Auster

What is required is a special pair of spectacles which, of course, will also act as blinkers. I became fascinated by the multifarious uses of fake crocodile skin and made a collection for a showcase in an exhibition about materials. With this new preoccupation I easily found wooden crocodile chair seats, plastic crocodile wash bags, iron crocodile trunks, paper crocodile filing cabinets, a crocodile glass and a crocodile china vase. The only item missing was a brass tray or ewer (a tray made of brass beaten until it looks like crocodile skin?) Because I have always hated brass, my special spectacles ceased to work and I found myself in a shop famous for selling the stuff, unable to notice the three trays and eleven ewers in front of me until they were pointed out by the shopkeeper. I have no eyes for brass.

Collecting

Collecting is an adjunct to noticing things, and objects in particular act as inspiration or joggers of memory. I'm often asked if my house is full of showcases. This slightly misses the point: although I'm a great hoarder, collecting genuinely is a design tool for me, so that once something has served its purpose in a drawing or has been transferred to slide to make a point in a lecture, it disappears into deep storage. Nor do I have the most virulent form of the collecting bug: I am not completist, I don't need the whole set. The cheapest useful collection is a list.

I started to look at how artists represent trees: wood engravers in general, Paul Nash, his pupils Eric Ravillious and Edward Bawden, early Graham Sutherland. I discovered that they had all drawn trees to decorate ceramics and added Scottie Wilson to the list before moving on to look at traditional decorative trees on ceramics and pottery – I already had a big collection of broken blue and white china dug out of my garden which had been deployed in several illustrations. This virtual collection of artists' trees was used in a drawing of pottery shards set on a large carving plate with a tree-shaped gravy 'drain'.

I made two further collections: the first a collection of how toy makers 'draw' trees; the second of objects that look like trees. I've used these collections in many pieces of work and use the tree as a metaphor as often as I can.

The Trickett and Webb calendar of 1988 had the theme 'Half-' (as in -Nelson). I chose half-timbered as soon as the list arrived – a chance to deploy my collection of objects that look like trees.

Three months later: it's November and I still haven't started the artwork. I'm booked for a trip to New York for one of Edward Booth-Clibborn's British Illustration Weeks and Brian and Lynn (Webb and Trickett) are beginning to panic about the calendar. They are going to the same event and we are all staying at the Gramercy Park Hotel. I

decide to take a selection of my tree-like objects with me, to be seen panicking myself.

My hand luggage therefore contains a silver-plated cocktail spoon, a conical steel drill bit, a triangular metal cake icing tool, an iron plumb line nail, a galvanised wire gadget with a rubber suction foot for holding a flower arrangement in a vase (do these have a name?), along with a carpet sample, a child's wooden top, a pencil head eraser and a rubber woodgrainer.

The security x-ray finds this miscellany hard to handle (is it a Kalashnikov in bits?) and my bag is opened by a security guard who quite naturally asks, 'What are all these things for?' Biting back an answer that begins, 'Well, I'm a graphic designer...' (You can easily miss a plane explaining what a graphic designer is), I reply, 'Well, I'm an artist and I'm taking all these things to New York to make a drawing of them.' He paused. 'I thought artists were meant to make things up.'

A critical divide supplied by a security guard. Do we draw things or make them up? Do we copy or invent?

[1] Fuller: 1969-MA.

[2] Vicente Ferrer, *My First 80,000 Words*. Spain: editorial Media Vaca.

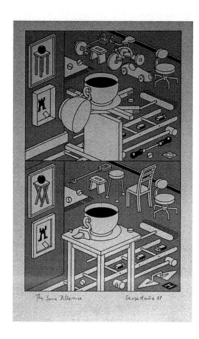

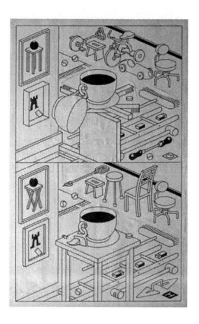

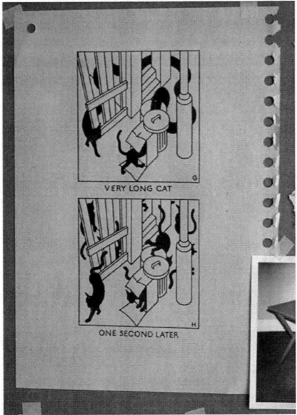

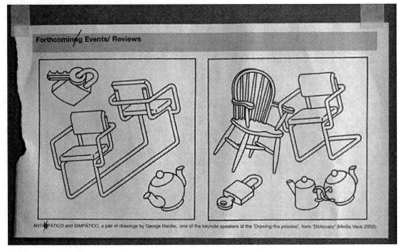

ANTIPÁTICO and SIMPÁTICO, a pair of drawings by George Hardie, one of the keynote speakers at the "Drawing the process", from "Dictionary" (Media Vaca 2002).

antagonism
aspiration
choice
ethics
debate
friendship
leadership
order
privilege
search
selection